Beauty of
the Beast

PARKSTONE
INTERNATIONAL

Author: John Bascom

Layout:
Baseline Co. Ltd
61A-63A Vo Van Tan Street
4th Floor
District 3, Ho Chi Minh City
Vietnam

ISBN: 978-1-906981-45-7

Printed in Italy

"Beauty is animalistic, beautiful is celestial."

— Joseph Joubert, *Pensées*

Featured Artists

Leonardo

Rembrandt

G. Courbet

ChAGAll

Andy Warhol

manet

Klee

H Rousseau

SIMPLE NOTION OF BEAUTY

I n defining beauty, we say of it, first, that it is a simple and primary quality. It is uncompounded. No two or three qualities in any method present can compass it with their combined effects. No analysis can resolve it into other perceptions, but there always remains something unresolved and unexplained, which is beauty. This is proved by the fact that the most successful of these resolutions, while they hit on qualities

The Three Black Auks (detail)

Anonymous, c. 27,000-19,000 BCE
Cosquer Cave, Calanque de Morgiou

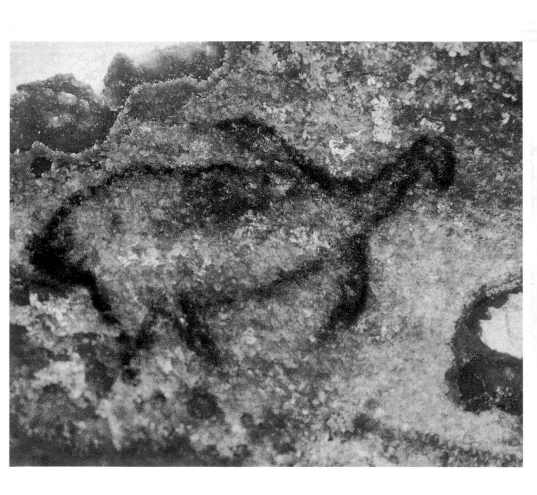

9

frequently concomitant with beauty and intimately related to it, are never able to go beyond this companionship and show the identity of those qualities with beauty, whenever and wherever found. Unity and variety are qualities usually, I think always, in some degree present in beautiful objects. But though this presence may show them to be a condition for the existence of beauty, it does not show them to be its synonym or equivalent. In fact, we find that these qualities exist in many things which have no beauty.

Bison Carved in Low Relief
———————————
Anonymous, c. 16,000 BCE
Limestone, length: 30 cm
Musée national de la Préhistoire, Les Eyzies-de-Tayac

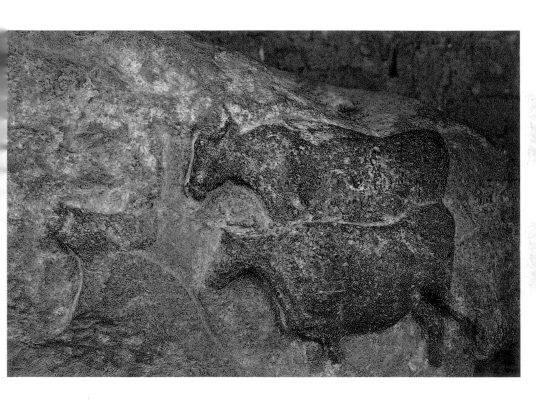

Their range may include the field under discussion, but it certainly includes much more, and thereby shows that these qualities do not produce the distinguishing and peculiar effects of aesthetics. Thus is it with every combination of qualities into which we seek to analyse beauty. Either phenomena which should be included are left unexplained, or phenomena which do not belong to the department are taken in by the theory. These analyses, either by doing too much or too little, indicate that the precise thing to be done has not been

The Antelopes

Anonymous, c. 1550-1500 BCE
Fresco, 275 x 200 cm
National Museum of Athens, Athens

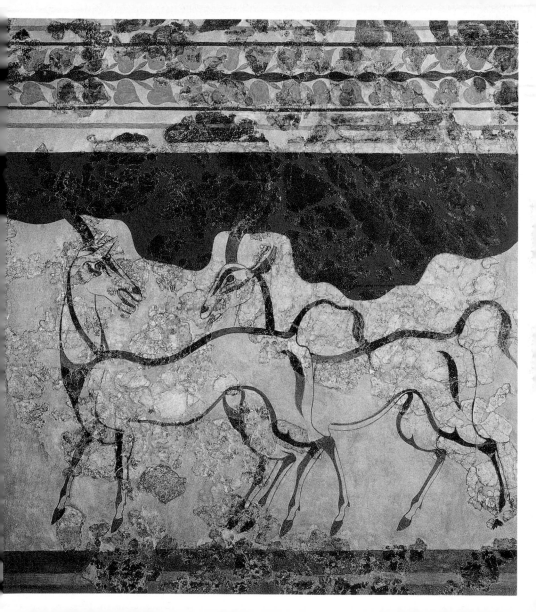

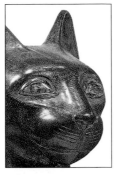

done by them, and only prove a more or less general companionship, and not an identity of qualities. It is one thing to show that certain things, even, always accompany beauty, and quite another to show that these always and everywhere manifest themselves as beauty, reaching it in its manifold forms, and leaving nowhere any residuum of phenomena to be explained by a new quality. The idea of beauty has been with patient effort and elaborate argument referred to in association, thus not only making it a derived notion,

The Cat Goddess Bastet

Anonymous, 663-609 BCE
Bronze and blue glass, 27.6 x 20 cm
Musée du Louvre, Paris

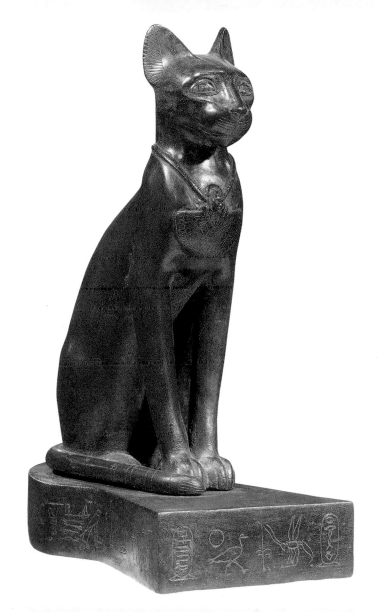

but one reached through a great variety of pleasurable impressions. It is clear, however, that association has no power to alter original feelings, but only to revive them. Therefore, if beauty is not as an original notion or apprehension entrusted to association, it cannot be given by it since this law of the mind has no creating or transforming, but simply a uniting power. Association can explain the presence of ideas, not their nature.

The Painted Garden of the Villa of Livia at Prima Porta

Anonymous, 1ˢᵗ century BCE. Fresco
Museo Nazionale Romano
Palazzo Massimo alle Terme, Rome

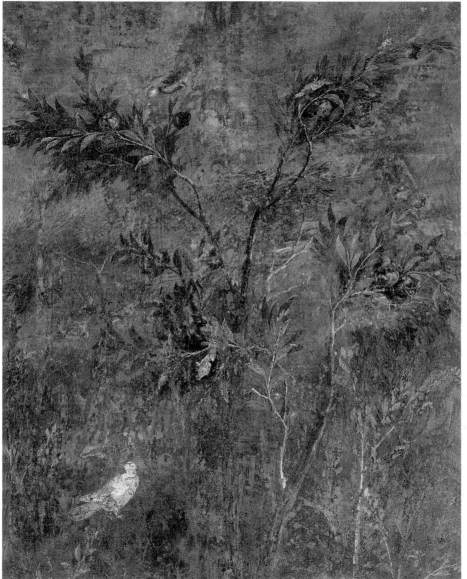

17

On this theory, beauty must chiefly be confined to the old and the familiar, since upon these associations it has acted and been correspondingly excluded from the new, as not yet enriched by its relations. This is not the fact. The beauty of an object has no dependence upon familiarity, but is governed by considerations distinctly discernible at the first examination.

In individual experience, it is a matter of accident what objects ultimately become associated with pleasant or with unpleasant memories; and in community, association is as capricious as fashion. No such caprice,

Ducks and Antelopes

Anonymous, 1st century BCE. Fresco
Museo Archeologico Nazionale, Naples

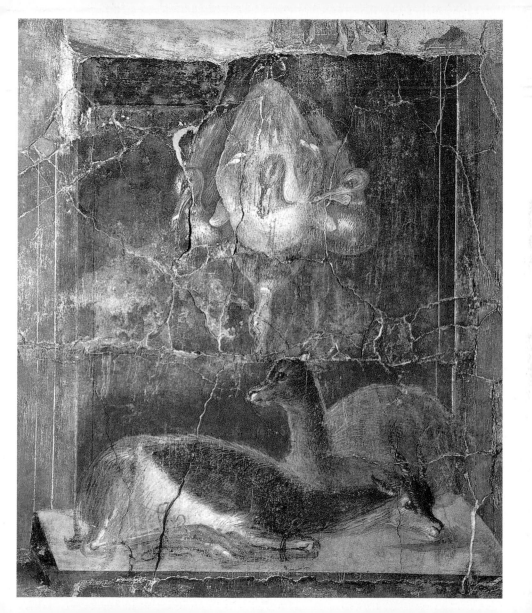

however, attaches to the decisions of taste. A uniformity indicative of many well-established principles belongs to these. So far as beautiful objects have been united by a firm association with wealth and elegance, this association itself must be explained by their prior and independent beauty. Beauty has occasioned this permanent and not groundless preference for wealth and elegance. The simplicity of this quality is seen in the presence of an unexplained and peculiar effect, after we have removed all the effects which can be ascribed to the known qualities present.

Detail of pictorial decoration with trompe l'oeil garden and fountain with birds

Anonymous, 25-50 CE. Fresco
House of the Golden Bracelets, Pompeii

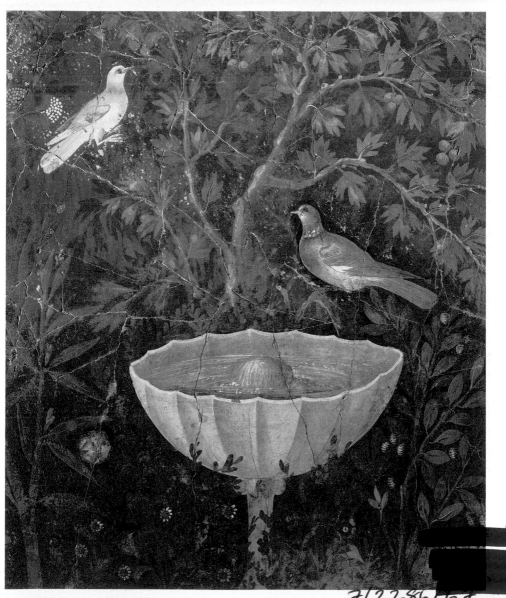

7122861617

It is underived. The primary nature of beauty presents a question of some difficulty, since there are qualities with which it is often so intimately associated that its own existence in particular cases is dependent on theirs. Compared to qualities with which it is often associated, beauty can have the appearance of a secondary and subsidiary quality. In many things, their relations give limit and law to their beauty, and, as we here find the impression of beauty dependent on an obvious utility, coming and going therewith, it would

Cat clawing a Turkey-Cock, Ducks, Birds, and Seashells

c. 50 CE. Roman mosaic from Pompeii
Museo Archeologico Nazionale, Naples

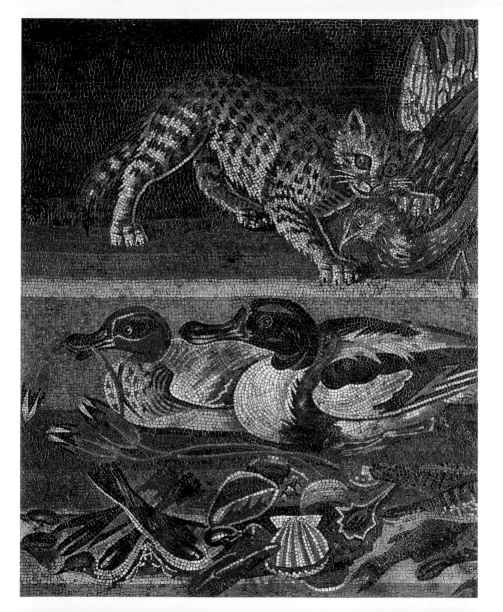

seem an easy and correct explanation to refer this peculiar intuition and feeling to the perception and pleasure of an evident adaptation of means to an end in the object before us. The error of such a reference is clearly seen, however, in another class of cases, in which this quality is found to have no such connection with the useful and to exist in a high degree with no reference, or with a very obscure and remote reference, in the object to any use. If we undertake to deduce beauty from any quality or relation of things, however

Ganesha

———

Hoysala Empire, 12th-13th century
Chloritic schist
Asian Art Museum of San Francisco
The Avery Brundage Collection

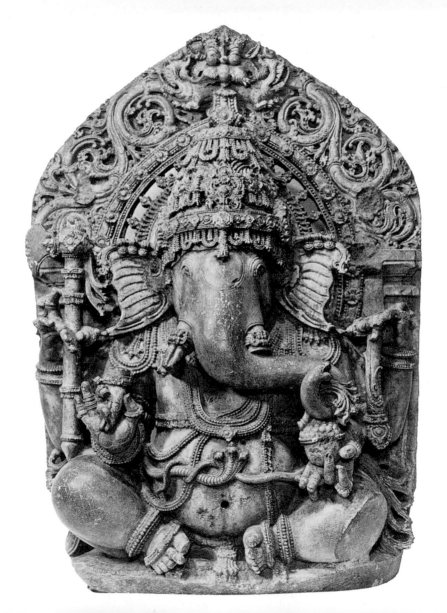

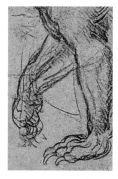

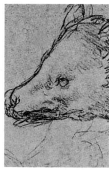

successful we may think ourselves in a few chosen instances, we will find a large number of objects which our theory should explain beyond its power.

A more careful examination of the very cases on which we rely will show us, that, while beauty may exist with, it exists in addition to the quality from which we would derive it; that the utility with which it is associated is not a cause, but a temporary condition of its existence, or rather that the same relations of the object include and determine both its beauty and its utility.

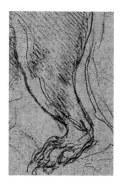

A Bear Walking

Leonardo da Vinci, c. 1490
Metalpoint, 10.3 x 13.3 cm
The Metropolitan Museum of Art, New York

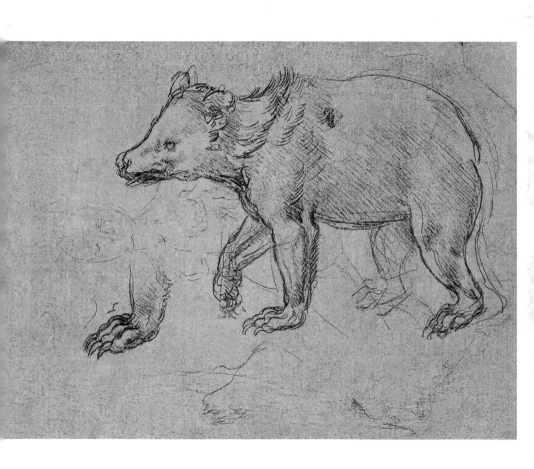

As it follows, therefore, in regular sequence, there is no one quality or set of qualities. Instead, we say that it itself is a primary and simple quality. There is involved in this assertion an inability to give any explanation of the attribute, or any definition of the word by which it is expressed. It is compound and derived from things which can be explained. Simple things can only be directly known and felt. Any explanation involves a decomposition of the thing explained, a consideration of its parts, and thus an apprehension of it as a whole,

Lion

———

Albrecht Dürer, c. 1494
Gouache and gold layer on parchment, 12.6 x 17.2 cm
Kunsthalle, Hamburg

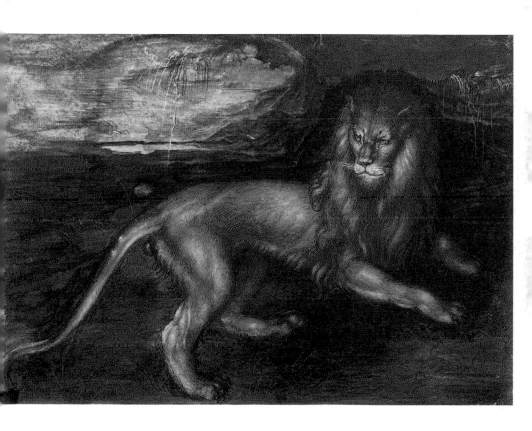

or the reference of it to some source or cause whence it proceeded, and in connection with which it is understood. But no simple thing can be decompounded and explained through its parts; or can a primary thing be referred as a derivative to something back of it, and thus be explained in its cause.

Nor is the word by which such simplicity is expressed, capable of any other definition than that of a synonym. A definition must include one or more characteristic and distinguishing qualities by which the thing in hand is separated from all others.

Sea Crab

Albrecht Dürer, 1495
Watercolour, gouache, 26.3 x 35.5 cm
Museum Boijmans Van Beuningen, Rotterdam

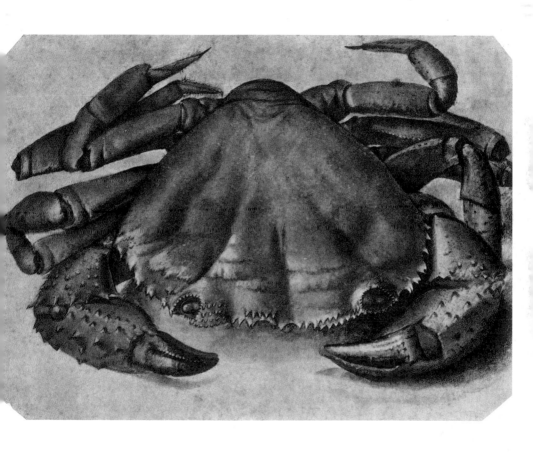

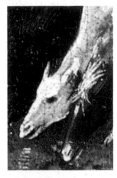

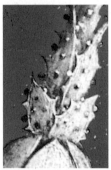

But in the case of a simple thing there is but one quality, and that alone can be mentioned, and this is to name a synonym.

All knowledge, therefore, of that which is simple and primary, whether in perception or intuition, must be direct. Mind must interpret mind, and only by the interpretation of similar faculties can this class of properties be apprehended. Certain original perceptions and intuitions must be granted us as the basis of every defining and explanatory process. Explanation cannot

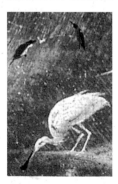

Detail of The Garden of Earthly Delights
(left panel: Paradise)

Hieronymus Bosch, c. 1500-1505
Oil on panel
Museo Nacional del Prado, Madrid

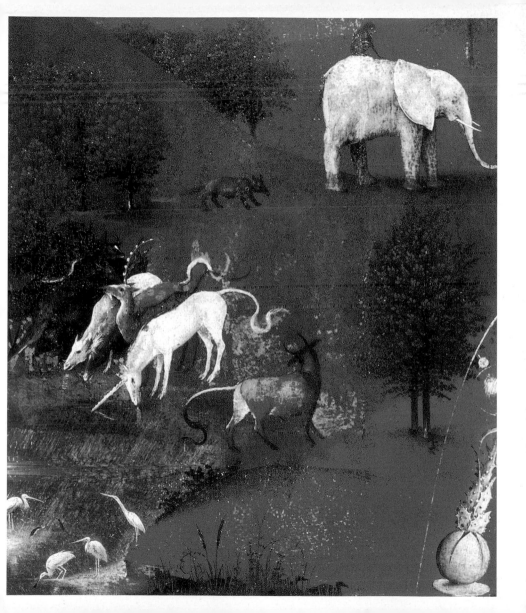

go back of its own postulates to throw light upon starting-points. Senses and faculties directly conversant with qualities the same for all, are these postulates. All simple and primary notions and attributes are directly known through these faculties, and the language which expresses them is only explicable to those who have the key, the chart, of kindred faculties. The term beauty is susceptible, then, of no definition, and the quality beauty of no further knowledge and explanation than that which the very power by which we perceive, feel, and know it is able to give.

A Young Hare

Albrecht Dürer, 1502
Watercolour and gouache on paper, 25 x 23cm
Grafische Sammlung, Albertina, Vienna

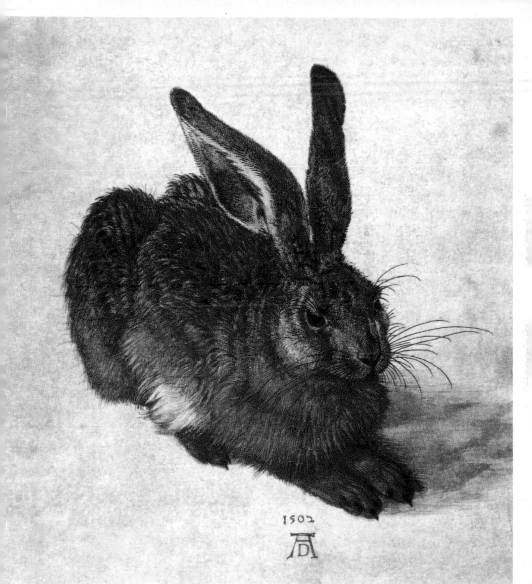

1502

The conditions and relations of such an attribute may still invite our attention. The simple and primary character of beauty does not exclude our second assertion, which is, that this quality is reasonable, that is, a quality for whose existence a reason can be rendered. Certain other qualities occasion it to exist and these may be pointed out. Right is a primary quality, yet all our judgments of right proceed on certain premises which sustain them, and which can be rendered as a reason why we suppose this characteristic of action present. Thus beauty, when present, is so through causes

Rearing Horse

Leonardo da Vinci, c. 1505
Pen and ink, red chalk, 15.3 x 14.2 cm
Royal Library, Windsor Castle

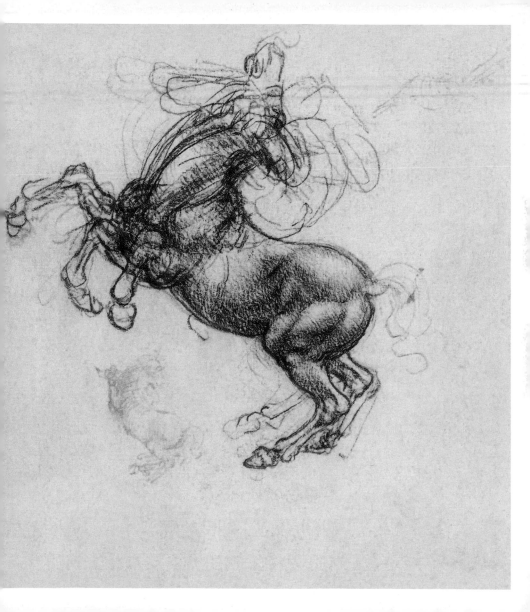

which can be more or less distinctly assigned, and is not, like the properties of matter, merely known to be, without any knowledge of that which occasions them to be. The proof of this is in the fact that there are questions of beauty, by the concession of all, admitting and calling forth discussion; that men not only discuss points of taste, but are persuaded by the reasoning employed. Indeed, if it were as true of intellectual as of physical tastes, that there is no dispute concerning them, our whole department would be at once annihilated and fall back among the things

Barn Owl (Syrnium aluco)

Albrecht Dürer, 1508
19.2 x 14 cm
Grafische Sammlung, Albertina, Vienna

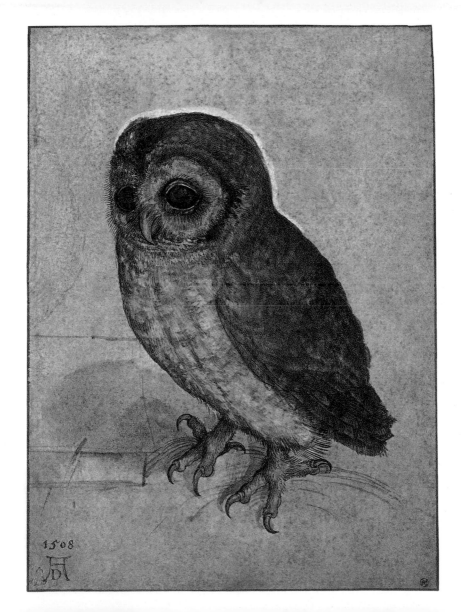

1508

incapable of explanation and knowledge. Our progress, and the propriety of every effort toward progress, rest on the assertion, that beauty is a subject of reasoning, and is, in its existence, reasonable. The important and pregnant nature of this assertion will appear more and more as we advance, and its truth will be involved in the very fact, that, following in the steps of all who have preceded us, we make evident that we regard beauty as a reasonable quality, by actually reasonably concerning its existence and the manner of its action.

The Heron

Albrecht Dürer, c. 1515
Watercolour on parchment, 26.7 x 34.7 cm
Staatliche Museen, Berlin

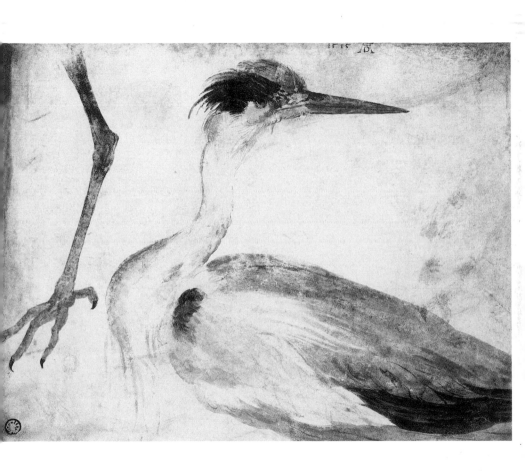

41

TRUTH AS A CONDITION OF BEAUTY

An important characteristic of beauty is truth. This assertion, however, is only applicable to art, since nature is our standard of truth, and all natural beauty necessarily possesses this quality. So various and vague are the notions attached to the phrase *Truth in art*, that we shall not be able to make satisfactory progress without carefully defining its several meanings.

Rhinoceros

Albrecht Dürer, 1515
Engraving, 21.4 x 29.8 cm
The British Museum, London

Int Iaer ons Heeren 1515 den eersten dach Mey, is den Coninck van Portugael tot Lisbona gebracht uyt Indien een aldusdanigen dier gheetē *Rinocherus*, ende is van coleure gelijck een schiltpadde met stercke schelpen becleet, ende is vande groote van eenen Oliphant, maer leeger van beenen, seer sterck ende weerachtich, ende heeft eenen scherpen hoorn voor op sijnen neuse, dien wettet hy als hy by eenige steenen comt, dit dier is des Oliphants doodt-vyandt, ende den Oliphant ontsieget seere, want als dit dier den Oliphant aen comt, soo loopet hem metten hoorn tusschen de voorste beenen, ende scheurt hem alsoo den buyck op, ende doodt alsoo den Oliphant: Dit dier is alsoo gewapent dat hem den Oliphant niet misdoen en can, oock isset seer snel, lichtveerdich, ende daer by listich, &c. Desen voorgestelden *Rinocherus* wert van den voornoemden Coninck gesonden naer Hoochduytslant by den Keyser *Maximilianus*, ende vanden hoogh-geroemden *Albertum Durer* naer t'leven geconterfeyt alsmen hier sien mach.

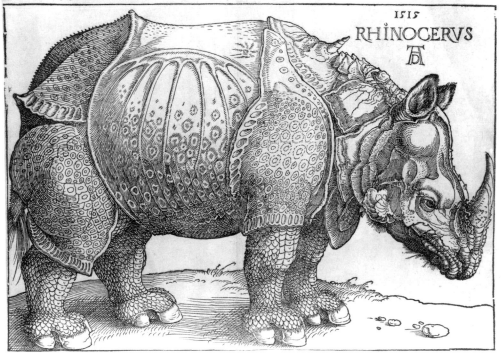

1515
RHINOCERVS

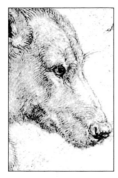

Some references of art to nature – some agreement of our conceptions with facts – is supposed to be included in the words, though the precise connection intended, of man's creations with those of the external world is not seen.

A common meaning of the truth is that by which it is confounded with the best, the noblest, the right. In this sense, to say that truth is a characteristic of beauty, may be either to utter the truism, that that which is best or beautiful is best or beautiful; or if, proceeding more wittingly, we first define what is the best, the noblest,

Lying Dog

Albrecht Dürer, 1520-1521
Silverpoint, 12.3 x 17.5 cm
The British Museum, London

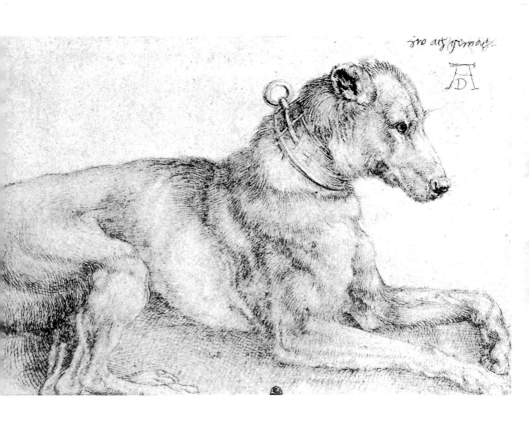

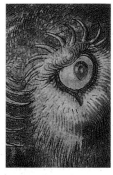

the true, and afterward call this beautiful, it may be to perform the work already undertaken by us in showing what that is in expression which is beautiful. Of the true, then, as employed to designate that which is correct or high-toned in expression, we have no further occasion to speak.

A second meaning of truth is, that which excludes falsehood from art and suffers no surface work to indicate, either in structure or material, that which does not exist beneath it. In this signification, that which is

Head of a Walrus
———————

Albrecht Dürer, 1521
Pen and ink drawing with watercolour, 21.1 x 31.2 cm
The British Museum, London

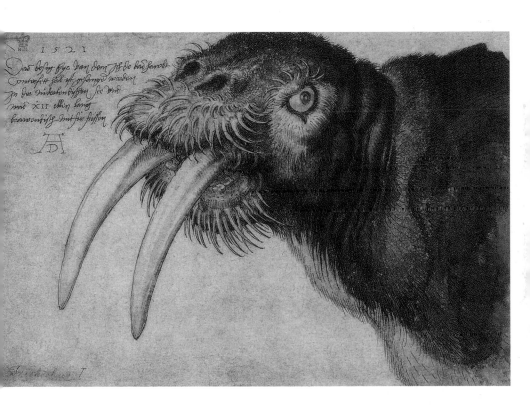

47

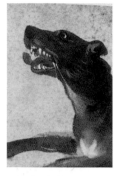

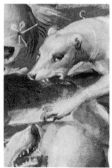

true is genuine, and is especially at war with veneering, paint, stucco, fresco, and cast ornaments; at least, so far as they purport to be other than what they are. An encouragement of these makes deception an end of art, and naked imitation its means, thus destroying the artist; gives rise to pretence, ostentation, and an ungrounded self-satisfaction in the employer of art, thus degrading him from the patron of virtuous taste to the pander of a false and foolish vanity. The enjoyment of art is also reduced to the detection of a clever resemblance, leaving

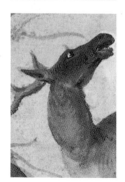

Composition from *Animals*

Giuseppe Arcimboldo. Watercolor and gouache
Österreichische Nationalbibliothek, Vienna

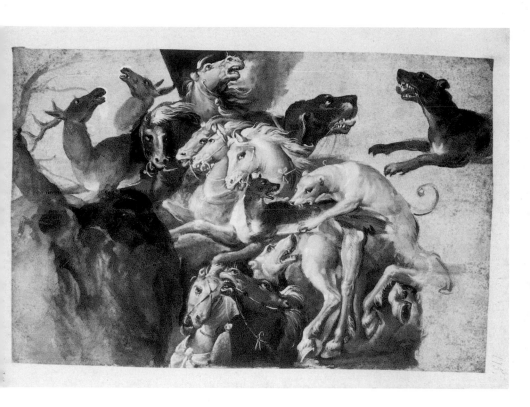

49

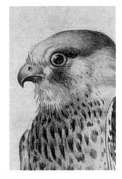

the critic now pleased with his own acuteness, now chagrined by his failure to discover the imposture.

It should certainly be an important principle with the lover of art to prefer the genuine to the false, a plain and substantial reality to elaborate and unsubstantial ornament; but so far have these surface dressings now entered into art as to render their exclusion both undesirable and impossible. Architecture is alone affected by them; and as this is primarily a useful art, ruled by economic principles, and only secondarily a

Study of a Lesser Kestrel (Falco naumanni)
and Flowers

Giuseppe Arcimboldo
Österreichische Nationalbibliothek, Vienna

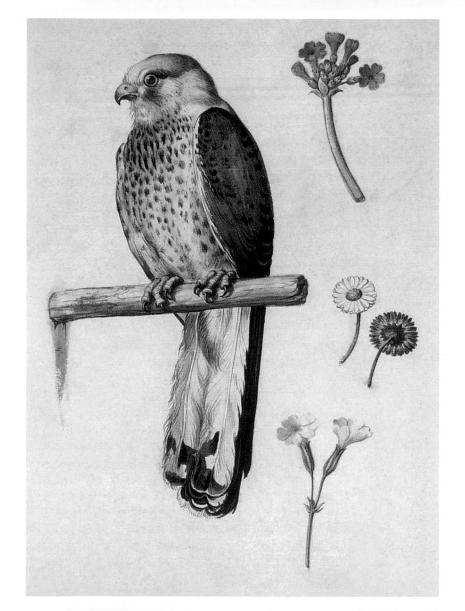

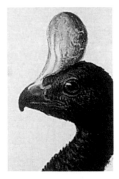

fine art, it can never be made entirely amenable to the laws of the latter. It is evident, however, that all finish which is intended to suggest what does not really exist should be carefully excluded from high and valuable art, from public and monumental architecture. Let us, at least, know that that which claims to be good is honest; that that which arrogates merit is not a bold lie, challenging detection; that the people have not combined to do both a weak and a false thing.

Study of a Northern Helmeted Curassow
(Pauxi pauxi)

Giuseppe Arcimboldo
Österreichische Nationalbibliothek, Vienna

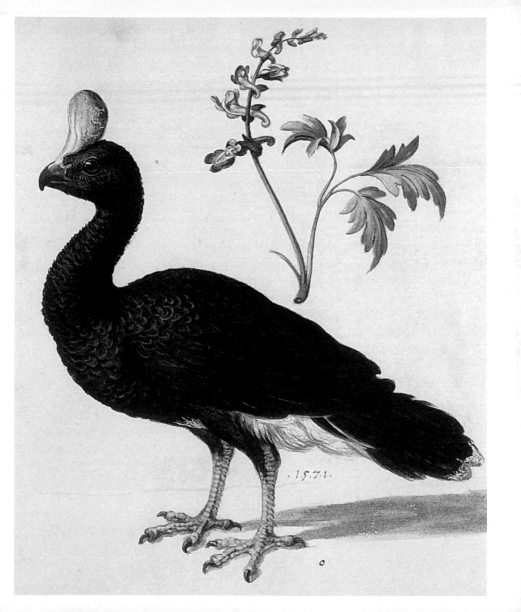

.15.71.

o

In domestic architecture, on the other hand, which is expected to be more temporary, claims less for itself, and must be more economic, veneers and imitations will always play an important part, and this, too, without detriment to the taste of a people, if one or two things are remembered. The radical difficulty with this method of workmanship is the deception aimed at it. It is this which gives rise to pretence and ostentation on one side, and disappointment and contempt on the other.

Red Hartebeest and Blackbuck
<hr />
Ulisse Aldrovandi
Second half of 16th century. Watercolour
Biblioteca Universitaria, Bologna

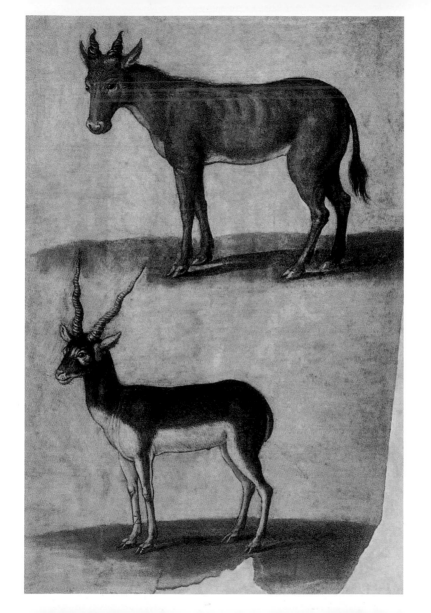

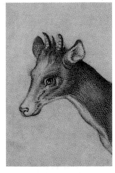

Our true success, then, in this kind of art is not, as is supposed, in a completeness of imitation which misleads the mind, but in an agreeableness of design and success of execution which, while pleasing, yet reveal themselves for what they truly are. Paint does not have the best effect when it is thought to be good stone or the native wood, but when it is seen to be paint well put on. It then does an honest, valuable, and praiseworthy work. While the veining of wood may suggest a pattern,

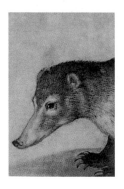

Red Hartebeest and Mountain Coati

Ulisse Aldrovandi
Second half of 16th century. Watercolour
Biblioteca Universitaria, Bologna

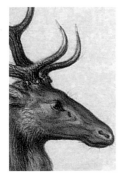

that graining is best which gives rise to no doubt, but in itself and in its relations at once shows that it is graining.

An agreeable impression may undoubtedly be secured by a cheap yet permanent surface work, and it would certainly be foolish to throw away papers and paints, which relieve and cheer the eye in every dwelling, because what is represented by them is often not real; nor is it difficult to draw important practical distinctions between the right and wrong methods of using these materials.

Cervus elaphus

Giuseppe Arcimboldo
Second half of 16th century. Watercolour on parchment
Österreichische Nationalbibliothek, Vienna

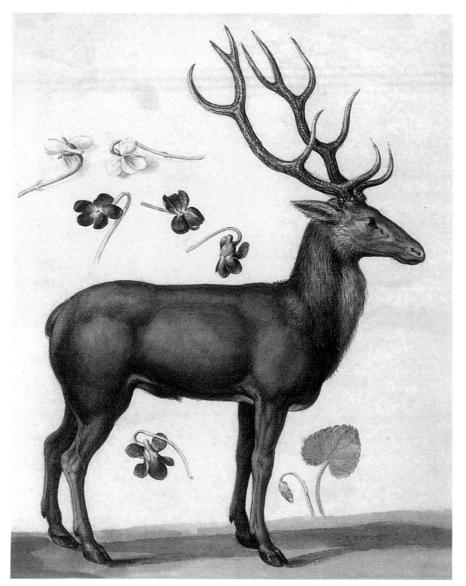

59

That which reveals its own nature is to be preferred to that whose success is dependent on a suggestion of something better than itself. Imitation should be turned aside from entire resemblance, and those features which mark the nature of the material be suffered, nay, made to appear freely. Iron-work will ever show itself to be iron, unless most assiduously disguised. A casting will naturally distinguish itself from a carving, and this it should ever be suffered to do.

Still Life with Birds
—————————————————
Lucas Cranach, c. 1530
Watercolour on paper, 36.6 x 20.3 cm
Staatliche Kunstsammlung, Kupferstichkabinett, Dresden

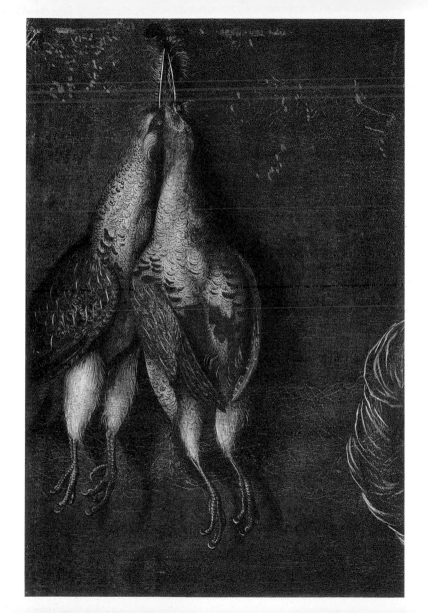

61

The parts of the design must always be heavier and better sustained in stone, than when wrought in the tenacious fibres of iron. The inherent strength of the one material tends to a lightness of pattern quite impossible with the other. The more markedly every material possesses and wears its own characteristics, the better is it, and there is no so sure way of destroying both the higher and the lower, as a constant effort on the part of the one to assume the forms and draw to itself the attention which can only properly belong to the other.

Two Chained Monkeys

Pieter Bruegel the Elder, 1562
Oil on wood, 20 x 23 cm
Staatliche Museen, Gemäldegalerie, Berlin

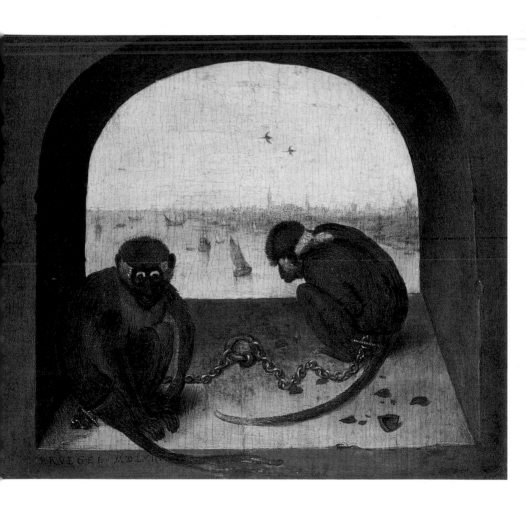

63

That which is genuine should not be mingled with that which is imitative. This is often done on purpose to aid the deception, and must always have the effect to confuse the mind, and render it suspicious. Such a method is opposed to the frank, open spirit already urged, which everywhere avows its material by its manner of treatment. Furthermore, that which is inaccessible and beyond our judgment should be in kind like that near at hand.

Paradise

Jan Brueghel the Younger, 1650
Oil on canvas, 60 x 42.4 cm
Gemäldegalerie, Staatliche Museen, Berlin

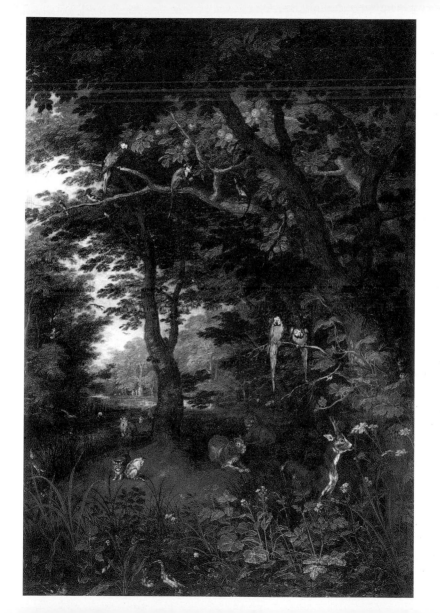

No impression is more unfortunate than that our action will turn into an indolent subterfuge the moment it is out from under inspection. It is better to make the deception elaborate, place it where it may be examined, and defy detection, than to hide a cheap and lazy imitation in the distance, and then affirm it to be genuine by a witness near at hand. The spectator, when discovering the character of such work, feels that he has not been cheated by the cunning of the artist, but by his sheer, shirking dishonesty.

Lion Attacking a Horse

Attributed to Antonio Susini or Giovanni Francesco Susini, after models by Giambologna, 1600-1625
Bronze, 22.9 x 28 cm
J. Paul Getty Museum, Los Angeles

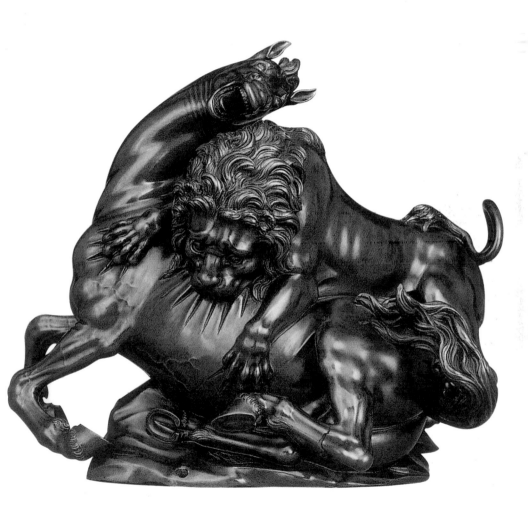

If these principles are regarded, an inability successfully to carry imitation into deception, and custom telling us what to expect, and in what places, will do the rest, and the various methods of surface treatment will be as genuine as any work in wood or stone, for they will only indicate what they really are. They may, also, well be the more dear to us, because they give early play to the fancy, and, accessible to all, are the modest adornments of the homes of the many. That truth which acknowledges its material, which honours the genuine, which marks the imitative as such, is an element of all correct taste.

The Garden of Paradise with the Embarkment
of the Animals into Noah's Ark

Jan Brueghel the Elder, 1596
Oil on copper, 27 x 35 cm
Private collection

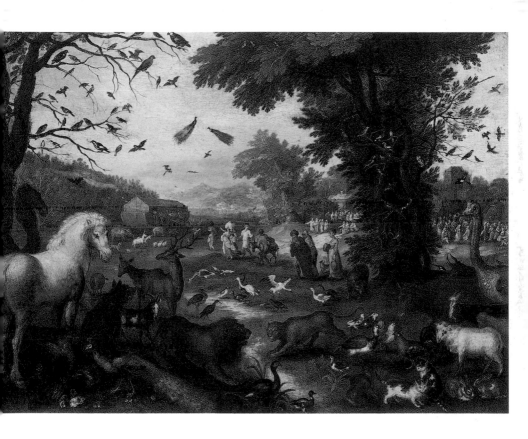

CONNECTIONS OF ART AND NATURE

This meaning of truth is, however, subordinate to yet another meaning employed in questions of art, the one more immediately referred to in speaking of it as a characteristic of beauty. This is an agreement between the signs and symbols of art and those of nature. The language of the two must be the same. What we have seen in the actual world must interpret what we see in the ideal world, and what is here present must have the fullness and force of what we have elsewhere felt. It is this common speech of art

Lioness

Peter Paul Rubens, c. 1614-1615
Black and yellow chalk, grey wash,
heightened with white, 39.6 x 23.5 cm
The British Museum, London

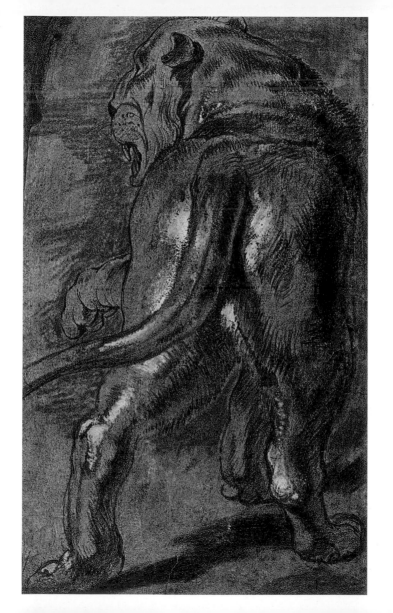

and nature – this use of the same forms and colours, the same traces of life and indices of feeling – that makes them one in their hold on the mind, and renders it impossible to enter into the first, save through the gateway of the second.

The plans in nature, while elaborate and varied, are sternly self-consistent, are, within the limits she herself has defined, forever the same. Each kind of tree has its own method of branching, each trunk its own bark-surface, each rock its own fracture, each moss its

Squirrels in a Chenar Tree

Mansur, c. 1615
Paint and gold on paper, 36.5 x 22.5 cm
India Office Library, London

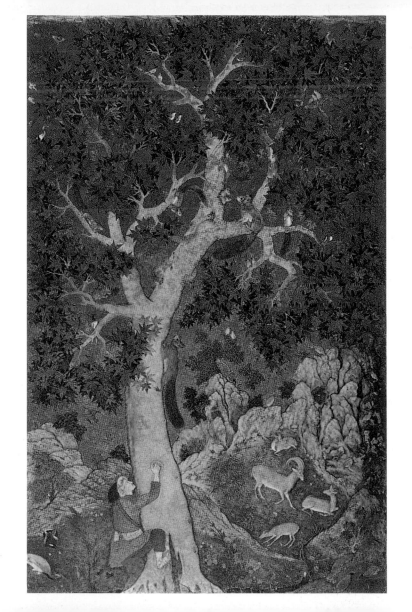

own pattern. Truth in all representation lies in the knowledge of these; and in representing them – we are not limited to a fact, but to facts, not to a form, but to a method; and he who knows, neither by observation nor inspiration how nature works, cannot himself work. No origination of symbols is open to the artist: he speaks as God has spoken from the beginning. There is but one alphabet of beauty, and that is found in nature. The relation of art to nature we must unfold more fully.

Head of a Stag

Diego Velázquez, 1626-1627
Oil on canvas
Museo Nacional del Prado, Madrid

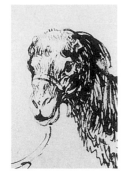

The first condition of beauty, for all intents and purposes, is expression. This is fundamental, it is that which underlies beauty, and comes out in it. The second is considered to be unity in variety, or, more simply, unity. This is not something in addition to expression, but the method of that expression, that without which expression itself is not beautiful. The third, discussed until now, is truth. This again is subordinate to, and modifies, the expression; unity was its method, truth is its means. It is utterance through natural and real, not

Un Chameau à Deux Bosses
(A Camel with Two Humps)

Rembrandt, 1633
Brown ink, white gouache touch, 19.4 x 28.9 cm
Kunsthalle (draw missing since World War II), Bremen

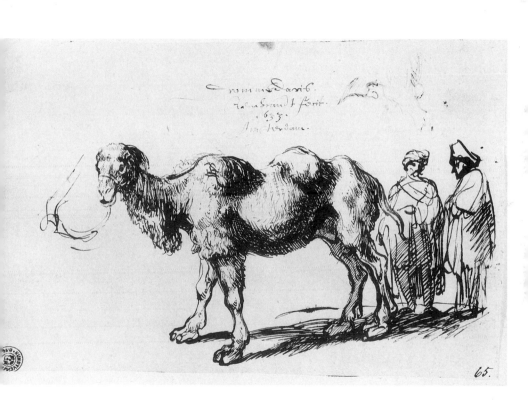

65.

through artificial and arbitrary signs. The expression stands in most immediate connection with things and facts, and thus is true. Beautiful expression in art is the unity of true signs in the utterance of worthy emotion. Nature in her work gives us the method, and our adherence must be faithful – gives us the language of all dead and living forces, and our use of this must be, to the last degree, accurate.

Two things may seem to contradict this assertion – the conventional and grotesque in art, and the arbitrary signs exclusively employed in poetry.

A White Horse

Diego Velázquez, 1634-1635
Oil on canvas
Palacio Real, Madrid

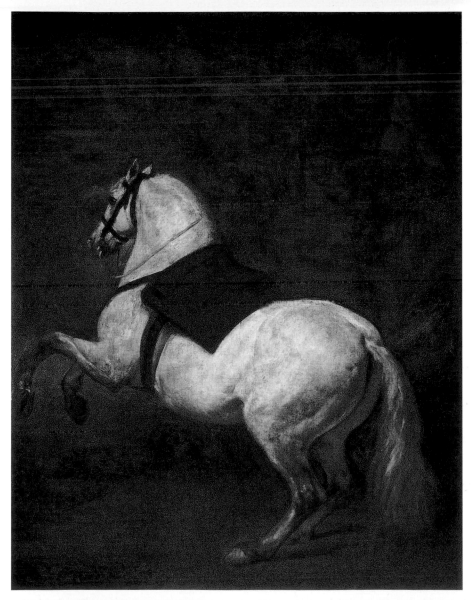

The conventional is that which by tacit agreement stands for something which it is not in itself able to represent. It especially appears in the carvings of architecture, where the completed form of the plant or animal escaping the chisel, a few strongly wrought lines take the place of finished work. The conventional – and the same is true of the grotesque – if wholly arbitrary, is not of itself beautiful, and becomes a mere member, like a moulding, to be judged solely by its relations – by the general effect. It has no agreement, more or less,

Sleeping Watchdog

Rembrandt, c. 1637-1640
Pen and brown ink with brush and brown wash, with touches of opaque white watercolour, on cream laid paper, 14.3 x 16.8 cm
Museum of Fine Arts, Boston

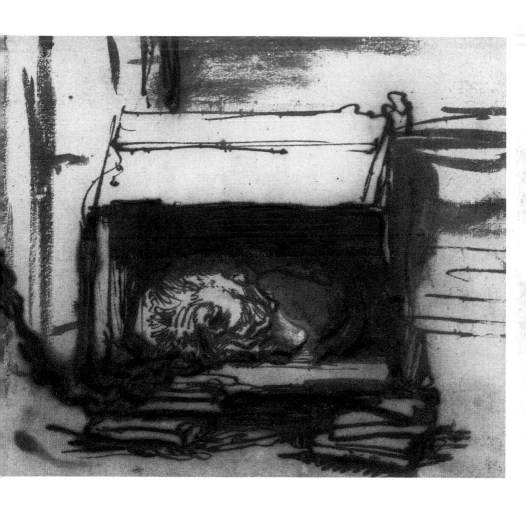

with nature, and hence there is no opportunity for truth. If, however, it boldly strikes at the reality, it may then become a curt truth, worthy in itself of consideration, though unable to tell all that might have been told. Intrinsic beauty here, however, as elsewhere, is dependent on the faithfulness of what is done, be it more or less.

In poetry, the signs are, indeed, wholly arbitrary; but the beauty is not in these, or what they present to the eye, but in the images presented through them to the mind, and these images must be faithful.

An Elephant

Rembrandt, 1637
Black chalk, 23.5 x 35.4 cm
Grafische Sammlung, Albertina, Vienna

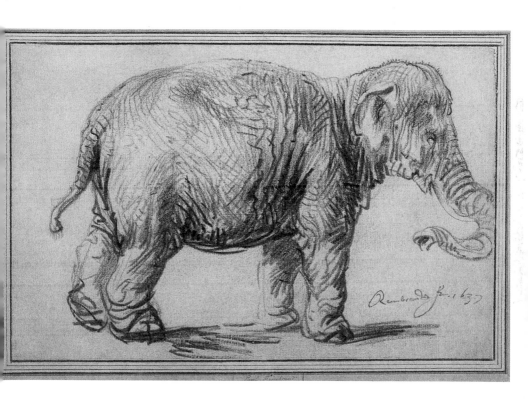

83

Rhythm, and a certain agreement of sounds with the thought, may enhance the effect to the ear, but only because there now begins to spring up a resemblance to the real – a somewhat obscure truth. So far as poetry is representative, the necessity of truth is as great here as elsewhere. The possible and the probable are counterparts of the real, and reached through it; these assign limits to all poetic presentation, be it epic or dramatic, lyric or descriptive. Things that are, are facts; things that may be, are truths. Both contain the same

Two Studies of a Bird of Paradise

Rembrandt, c. 1637
18.1 x 15.4 cm
Musée du Louvre, Paris

46

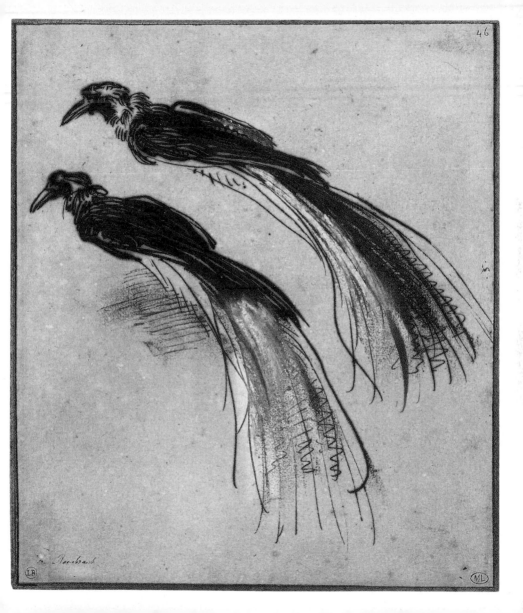

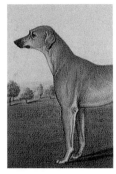

principles, the same laws of being and action, the same appeal to the thoughtful mind – the one, because it is; the other, through its agreement with that which is, because it utters the same lessons and the same laws.

The one contains beyond the other only the single item of a precise, historic existence. The actual, in its accidents, in its names and dates, has appeared but once; in its essentials, it is constantly reappearing, repeating itself at intervals everywhere through the complex pattern woven in the same loom under similar

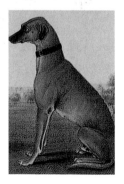

Two Dogs in a Meadow Landscape

Shaykh Muhammad Amir, c. 1840-1850
Watercolour on European paper, 29 x 45 cm
Victoria & Albert Museum, London

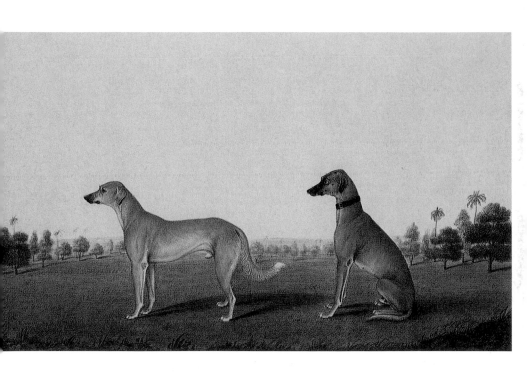

conditions. This it is which gives to the real its value, converting facts into principles and history into philosophy. This also is the truth of poetry. In emotion it utters that which may be, that, therefore, which a thousand times has been, and, in this its mastery of the actual, rules the heart. There is more truth in that which may often be, than in that which is known to have been but once. There is little value in any conception which has not that agreement with facts which makes it possible, probable, and truthful.

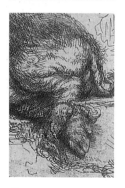

The Hog

Rembrandt, 1643
Etching and drypoint, 14.5 x 18.8 cm
Fogg Art Museum, Harvard University, Cambridge, MA

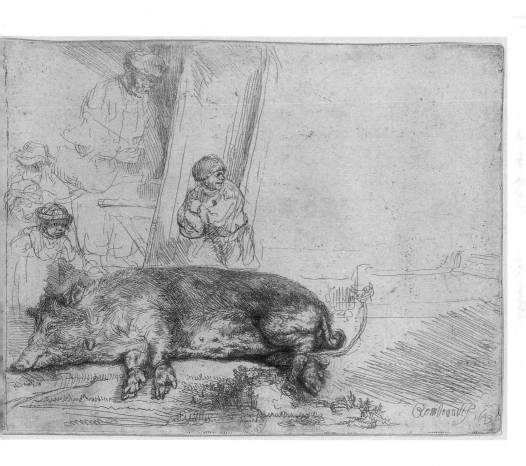

Architecture is, in many particulars, not a representative art, and is, therefore, having no counterpart or standard in nature, to be judged by its own effect. The same is true, in a yet higher degree, of music. Truth, then, as a characteristic of beauty, must not only be limited to the fine arts, but yet further limited to those which have a correspondence or resemblance to nature – that is, primarily, to poetry, painting, and sculpture.

Three Cows in a Pasture

Paulus Potter, 1648
Oil on canvas, 23.2 x 29.5 cm
Musée Fabre, Montpellier

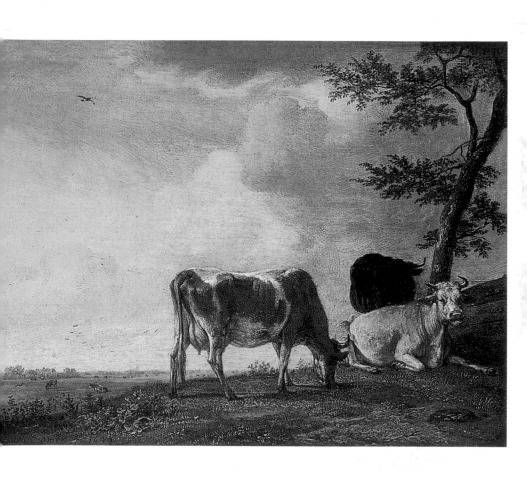

It is in connection with these arts, and the quality of truth belonging to them, that we can best apprehend the relation of the real to the ideal – of nature to art. The field which nature occupies, she occupies not to the exclusion of man, but for his instruction and guidance. Though much in the world of living forms is not complete, the suggestion of completeness is everywhere present. The mind is not suffered to feel that it perfects a plan which the Architect of the world was not able to perfect – that it discovers the failing strength of an art grand

Still Life with a Hare and Fruit

François Desportes, 1711
Oil on canvas, 115 x 99 cm
The State Hermitage Museum, St. Petersburg

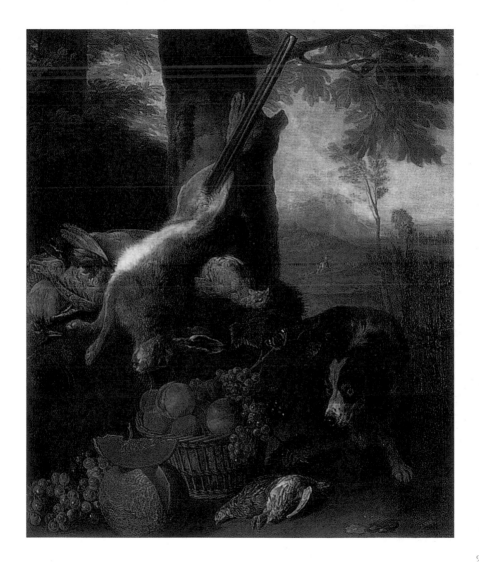

93

indeed in its rudiments, rather, it feels that the world is unfinished, and is called in to complete the great undertaking. The execution is not pushed to a point at which the concept fails, but the outlines and plans are ever in advance of the work; and man, as a journeyman artist, is employed in the study and realisation of these. Human genius, however powerful its command of beautiful forms, adds no new species either to the animal or the vegetable kingdom, no new phases either to land, water, or cloud scenery. Its strength is tasked in the study and mastery of that boundless variety already

The Dogs and the Game Birds

François Desportes, early 18th century
Oil on canvas, 72 x 93 cm
Pushkin Museum of Fine Arts, Moscow

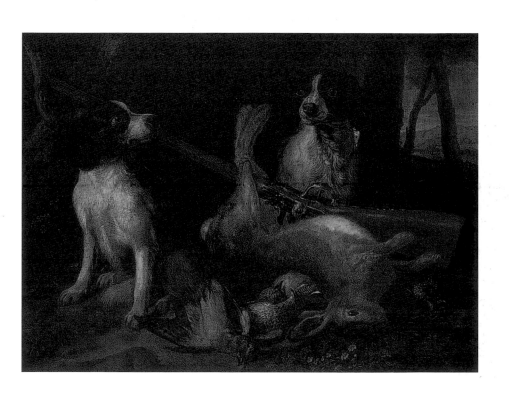

present. The expression in nature is so manifold and powerful as more than to occupy the mind in its acquisition – as more than to meet its utmost demand in bodying forth its own emotions; and man has thus neither ability nor occasion to add to the resources of aesthetical feeling laid open to him in the world of physical forces. The office of art is, here, not the invention in elements of that which is new, but the fresh and powerful use of that which is old – of that which is familiar, of that whose power passes under the hourly observation of men.

Dog Pointing a Partridge

Jean-Baptiste Oudry, 1725
Oil on canvas, 129 x 162 cm
The State Hermitage Museum, St. Petersburg

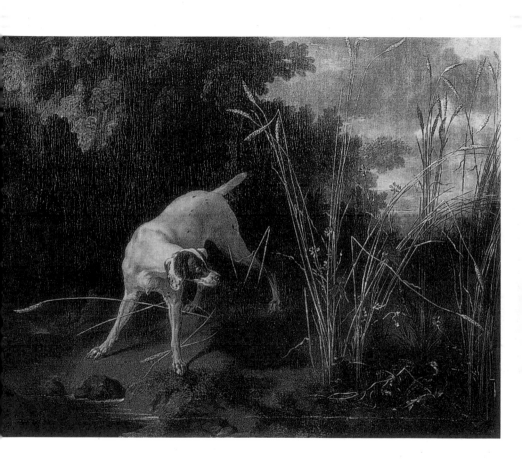

Nature is the source of beauty, and our guide in its pursuit, since she gives us, in all their variety, the forms under which inorganic and organic forces in the progress of a creative plan present themselves. The first steps in representative art are a full possession of all the facts in the department considered, of what in nature is there uttered, and of the method in which it is uttered. It is no more possible to be eloquent to the heart through the eye without a careful realisation of colour and form, than to reach it through the ear without the vocables of

Landscape with a Herd

Charles de Luna
Oil on panel, 27 x 21.5 cm
The Sevastopol Art Museum, Sevastopol

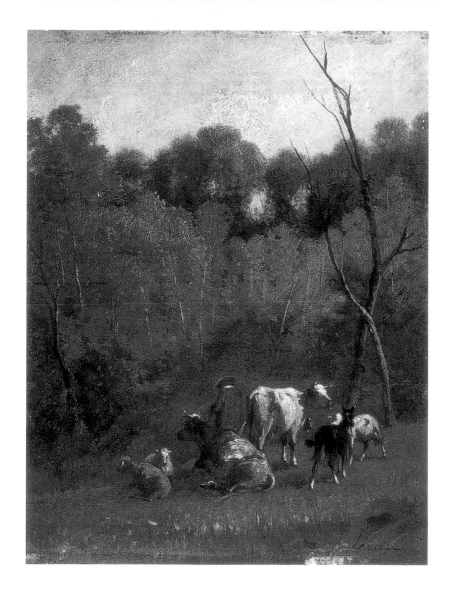

familiar speech. Art must be strictly and protractedly imitative, until it has mastered the symbols through which it works; and that art will be most powerful which has best learned this its first lesson; that has put itself in complete possession of the only means through which it can afterward express its own feelings. These means of expression, which are form and colour as existing in nature, we have spoken of as the signs, letters, symbols, rudiments, elements of art, in order that we might by these words mark the extent of the analysis which should take place in the study of the external world.

Dog and Game

Jean-Baptiste Siméon Chardin, 1730
Oil on canvas, 192.4 x 139.1 cm
Norton Simon Museum, Pasadena

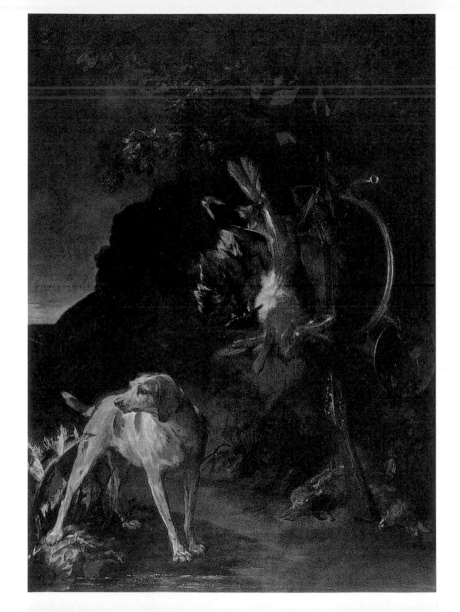

He who copies a single scene is strictly and solely imitative, adds nothing to what he has received, and is measured by it. The accurate sketch of a landscape, the painting of a portrait, both imply skill, but no more creative power than the rehearsal of an oration. A step beyond this is to discern the beauty of single features in the objects presented, and, retaining these, to reproduce them in new combinations. Here the same sort of taste is employed in selecting and rearranging the material as in using the thoughts of others. It is not,

The Ray
———
Jean-Baptiste Siméon Chardin, c. 1728
Oil on canvas, 114 x 146 cm
Musée du Louvre, Paris

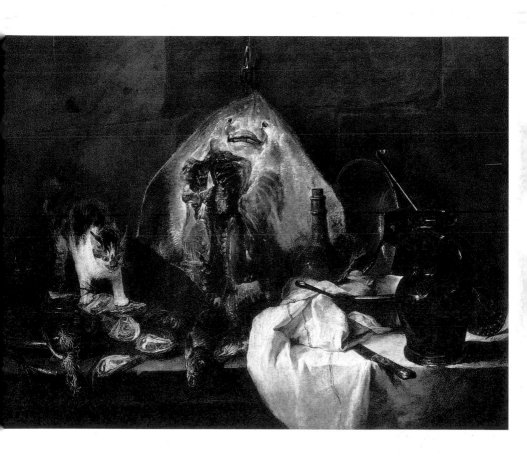

however, until the mind has gone further and seen in each form the law and method of the force which gave rise to it – has seized its characteristics, and is able to reproduce it in a member or in a whole with something of the freedom and boldness of nature, who scorns to imitate or repeat herself – that it has power over the means with which it may itself work. Such an art may paint landscape, without painting a landscape – man, and not a man. It has the breadth of the species, and

Mares and Foals in a River Landscape

George Stubbs, 1763-1768
Oil on canvas, 101.6 x 161.9 cm
Tate Gallery, London

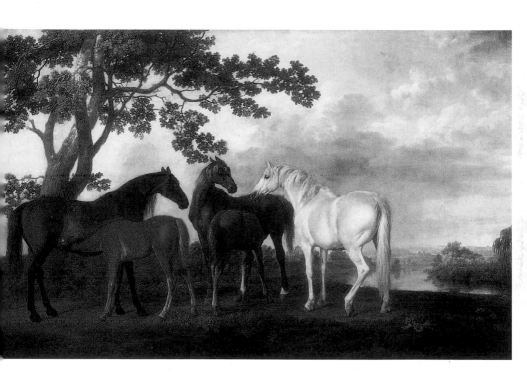

not the limitations of the individual, and while impersonating its own ideas, does so with the double range before its eye of the actual and the possible, of the seen and the suggested. This is to analyse expression into its elements, and, by the mastery of these, to hold the key of all combinations, both old and new. This is at once to rethink the thought of the writer, to bring to it the resources of a full vocabulary, and thus to make it forever one's own in possession and in use. It is an agreement of art with nature, in elements, in the changing

Macaque and Albino Baboon

George Stubbs, c. 1780
Cardboard, 69.8 x 99.1 cm
Royal College of Surgeons of England, London

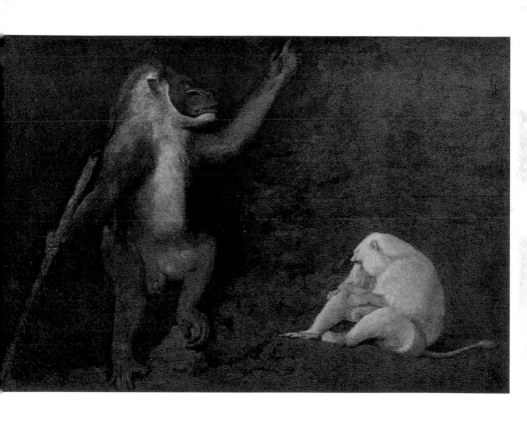

types of form and colour, full and various as these are, that constitutes truth, and makes it infinitely more than imitation. Truth is only fully present, when that power is possessed to which imitation is a means, and when, therefore, imitation is ready to be laid aside. To copy a rock, plant, or animal is one thing; to distinguish between its specific and individual characteristics, and to retain the one while ever varying the other is a much higher thing. An art that does this is truthful: its productions fall into the classes of science, and belong to the cabinet, and not to the museum.

Northern Cardinal (Cardinalis cardinalis)

John James Audubon
Plate 159 from *Birds of America*
Coloured engraving
Natural History Museum, London

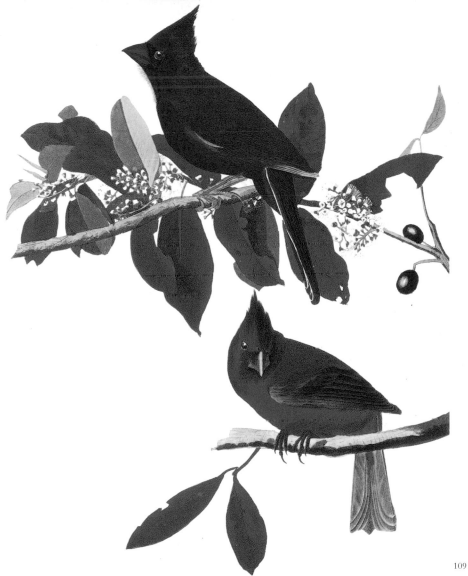

The first gift, then, of nature to art is the symbols of expression employed in works of beauty, through whose study and imitation they are acquired.

The second is the beauty conferred in external objects. The Divine thought, the Divine idea, is contained in these; and as the perfection of the end and of the means is discerned, as the concept is seen working itself out in successful and spontaneous completion, the mind is awakened to beauty, and receives

Study of a Dapple Grey

Théodore Géricault, c. 1812
Oil on canvas, 60 x 73.5 cm
Musée des Beaux-Arts, Rouen, France

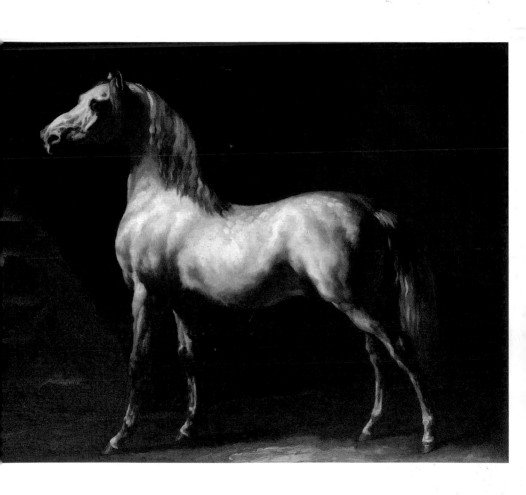

her most choice and safe instructions. In the same school in which the elements of expression are acquired, the inventive power is so quickened and trained as to possess that which it may utter. It is in the studio of nature, in the presence of forces ever expending themselves, ever renewing themselves in beautiful forms, that art catches its inspiration, and finds its own energies of feeling fostered into creative power.

Great Horned Owl (Bubo virginiaus)

John James Audubon
Plate 51 from *Birds of America*

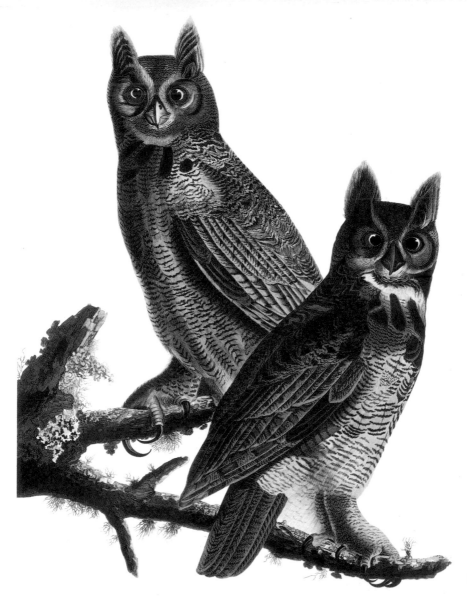

113

The third gift of nature arises partly from what may be termed the defect of her execution, and still more from the variety and fullness of beauty which she shows possible in all departments. Beauty in the external world is unprotected from accident, is left open, especially in man, to the trespass of the stern laws of retribution and the dire necessities of sin. It thus suggests much to the mind which itself does not reach, and gives to man an ideal in advance of the fact. Toward this ideal, man labours in joyful, though hopeless, pursuit since each

Peacock in the Snow

Katsushika Hokusai, excerpt from the Album of Images from Nature by Hokusai (Hokusai shashin gafu), 1814
Orihon, nishiki-e, 25.6 x 17 cm
Pulverer Collection, Cologne

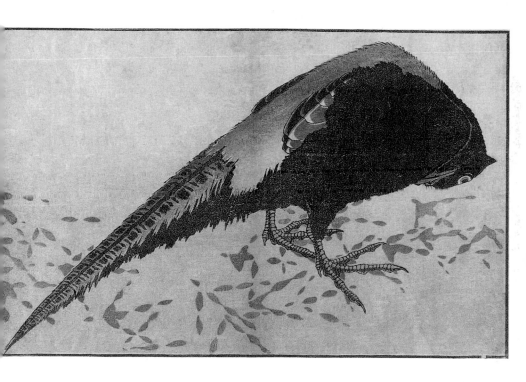

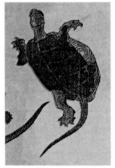

attainment enables him to enlarge, to perfect in conception the thing to be attained. This ideal is an angelic guide, with whom man travels an endless road between two antipodes, the imperfect and the perfect, the human and the divine. With only the real, man was stationary, but finding everywhere the suggestion of a better ideal, pursuing this, he becomes progressive.

The variety of expression open to effort concurs to the same effect. Beautiful objects are not all graduated to one scale. There is no optimism, excellency is shared

Turtles Swimming
―――――――――――
Katsushika Hokusai, 1832-1833
Nishiki-e, 49.9 x 22.7 cm
Honolulu Academy of Arts, Honolulu

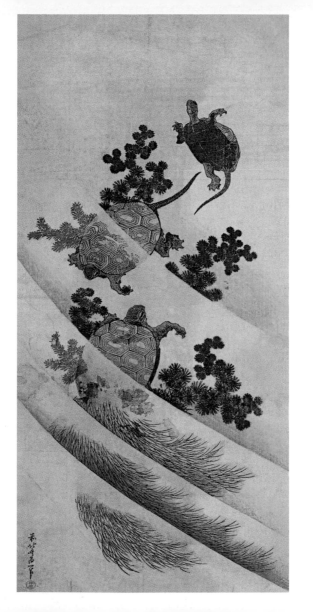

among compeers. Beauty is not a balanced abridgment of universal virtue, but is the lustre of single virtues. While, the mind delights in this or that expression, it does not thereby exclude from its pleasures even the counter expression. It presents as many shifting phases of feeling as the sky diverse forms of clouds. The variety in nature, while gratifying the mind, does not exhaust its power, and there still remain emotions which it would utter in its own way. The unceasing changes about it only teach it the power and scope of its materials,

A Grazing Bull

Jacques Raymond Brascassat, 1833
Oil on canvas, 112.5 x 146.5 cm

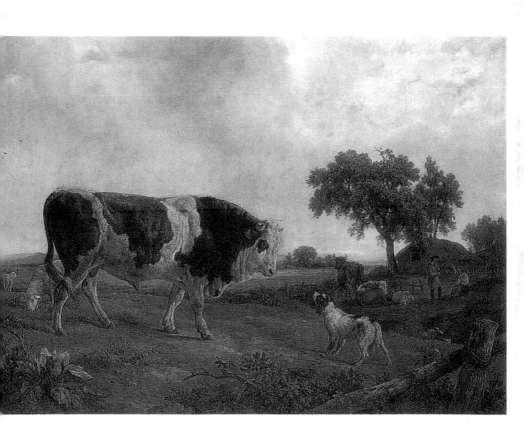

and these it makes haste to use in a kindred freedom of spirit. Nature, then, both in her defect and variety, teaches the mind to love and utter its own ideals, ideals which perpetually enlarge before it, as it sees more of the force and vigorous methods of the beauty working in nature, more of the Divine idea of facts, more of the goal prophetically present in man; ideals without which there would be possible no independent or valuable workmanship to man, no momentum of progress carrying

Two Carps

Katsushika Hokusai, c. 1833
Ushiwa-e, nishiki-e, 23.2 x 27.7 cm
Musée national des Arts asiatiques – Guimet, Paris

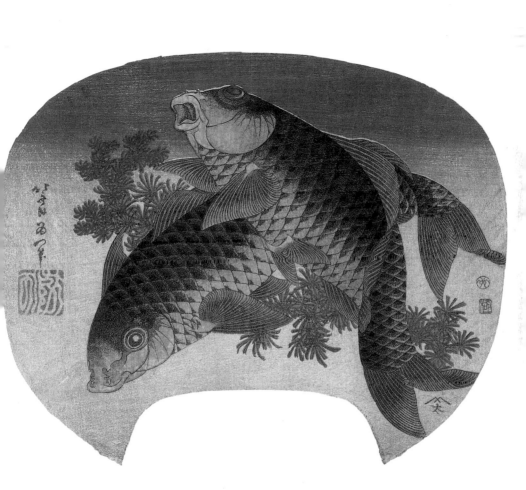

him by a hair's breadth beyond the actual. The ideal is but the impulse received in our movements through the real, expended in the world of thought, and there wrought into that higher conception for which alone training and discipline are given. Without this momentum of the mind which reveals itself in new ideas, all scholarship would be acquisition, all knowledge, memory, and all progress, patiently trudging along the one thoroughfare of thought.

Rooster, Hen and Autumnal Flowers

Utagawa Hiroshige, 1837
Colour woodblock print, 21.6 x 29.5 cm
Victoria & Albert Museum, London

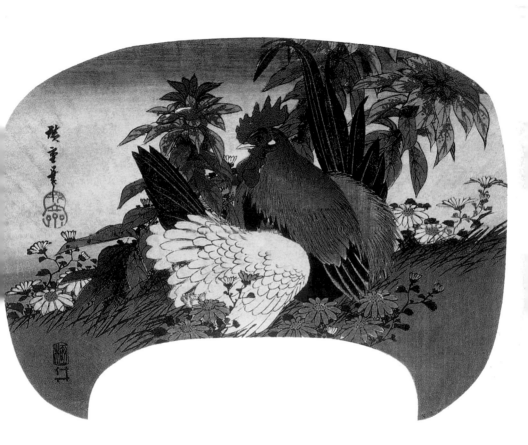

love of that which is healthy; while a lascivious, lustful heart will seek lascivious and lustful art. If the wisdom and grace of the thought, as it comes out in a noble product, are alone to elicit our admiration, there must be an intense sympathy in the spirit with that which is grace-giving and true, and a stern rejection of that which is wayward and ready to slip into base debauchery. The great bulk of error in morals is traceable back of

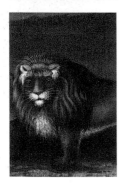

Red Deer II

Franz Marc, 1912
Oil on canvas, 70 x 100 cm
Bayerische Staatsgemäldesammlungen
Pinakothek der Moderne, Munich

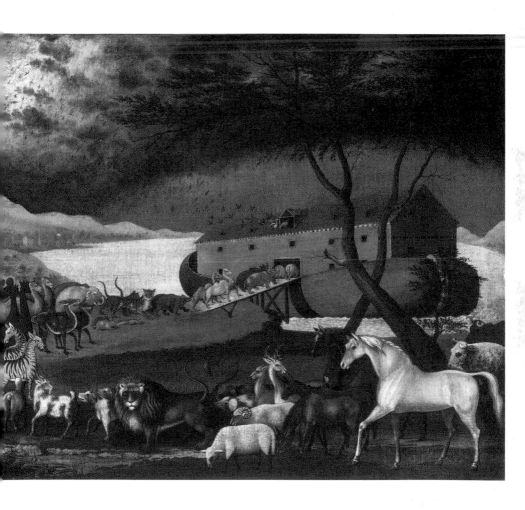

There are in man -

(a.) An appreciation of the facts in nature – of the execution there present;

(b.) Of the suggestion in nature of the impulse which it but partially obeys, partially completes. There is thus an ideal, an idea, a forming thought, furnished to man, and, at the same time, in the mastery of real symbols, a means, a material, on which this thought may work, in which it may realise itself.

The Peaceable Kingdom

Edward Hicks, 1847
Oil on canvas
Private collection

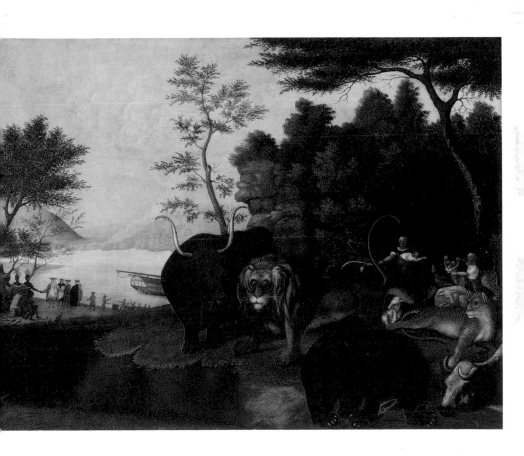

127

Truth is the agreement of these symbols, these methods, with those of nature; and by it the works of man, no longer fantastic, are made akin to those of God, are truths in that they repeat the same great laws, and are but phases of the forces which work the world. The ideal of man working itself out truthfully becomes, as it were, a new and most significant fact amid the facts of nature – working itself out nobly becomes a new and redeeming fact amid the facts of nature. The artist taught by nature, works with nature, rescues her from

Eagle on a Rock in a Snow Storm

Katsushika Hokusai, 1847
Paint on paper, 111.8 x 55.9 cm
Pacific Asia Museum, Pasadena

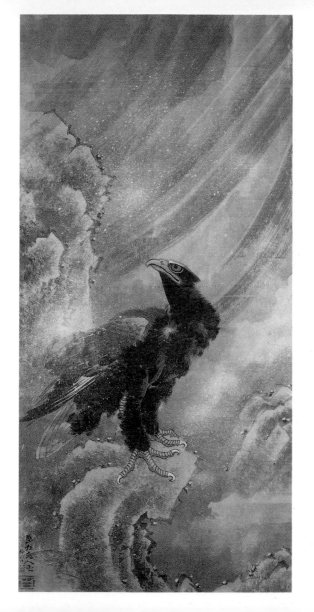

129

contravening and hostile forces, adds to her variety and, seizing her best thoughts, labours on them in statue and painting.

Landscape gardening, an art presentative rather than representative, will furnish us a closing illustration of nature's treatment of man. By a skilful use of plants, shrubs, and trees, almost any spot can be greatly ornamented. The valley, grove, and brook-side, though beautiful, are not as beautiful as they may readily be made to be. And man is encouraged to effort both by the means furnished and the necessity imposed. There is

Monkey

Katsushika Hokusai, 1848
Ink, colour and gofun on silk, 27.7 x 42 cm
Private collection

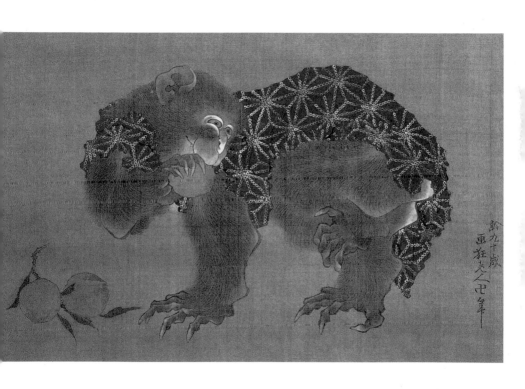

sufficient beauty present in the untrained growth to call out his taste, and awaken his desires; and in the same instant a labour is imposed upon him, if he would employ and perfect the material ready to his hand.

Nor is this all: nature refuses her own wild beauty to one who fails to train and culture it. Every place becomes better or worse under the hand of man. All noxious weeds – slovenly and ragged in habit, offensive in odour, rank in growth, prolific in generation, with burred seed-vessel catching to man and beast – gather

Cornell Farm

Edward Hicks, 1848
Oil on canvas, 93.3 x 124.4 cm
National Gallery of Art, Washington, D.C

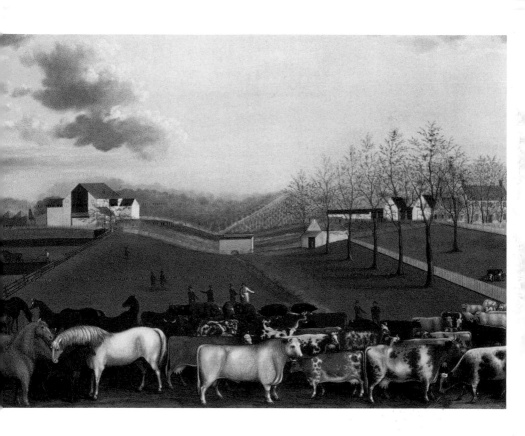

about and hunt down the sluggard – avengers of nature's wrong. These make an admonition of every neglected home, and, nodding in unseemly, unprofitable growth about the cheerless dwelling, seem to say, "Out of thine own mouth I condemn thee, and complete thine own work." There is no spot so void of beauty, so utterly deformed, as the unkempt abode of man. It forfeits the rugged yet chaste beauty of nature, and is smothered with the teeming ugliness which its own filth engenders.

Old Tiger in the Snow

Katsushika Hokusai, 1849
Ink, colour and gofun on silk, 39 x 50 cm
Private collection

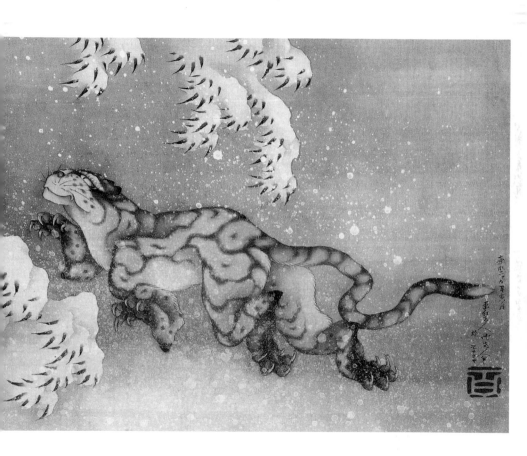

HOW BEAUTY IS REACHED AND CULTIVATED

H aving discussed beauty as a quality, that in which it inheres, and the signs by which it presents itself, we reach in order the faculty – the mental power, which arrives at this attribute. Here three suppositions are open to us. This quality is an external intuition, an object of one or all of the senses; or it is a deduction – the result of reflection, and reached by reasoning; or it is an internal intuition – the object of a superior rational sense.

The Villages of Minowa, Kanasugi and Mikawashima

Utagawa Hiroshige, 1857
Polychrome woodblock print,
ink and color on paper, 33.7 x 21.7 cm
The Metropolitan Museum of Art, New York

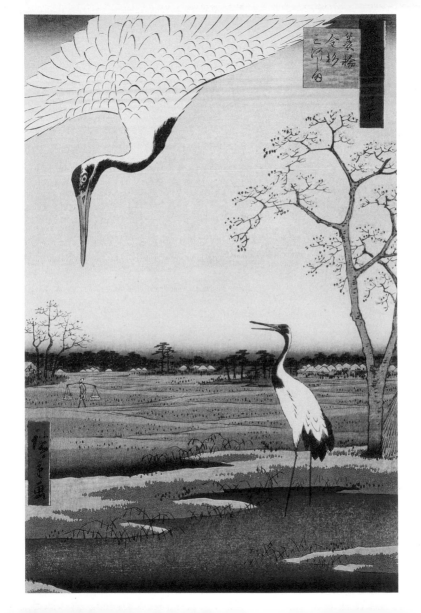

137

The first is not tenable; for, if beauty were the direct object of any one of the senses, everyone possessed of this sense would apprehend it directly and fully. Beauty would be as open to the perception of the brute as the man, of the uncultured as the cultured. The reverse of this is true, and no acuteness of senses is found to secure this perception.

The second is not tenable; for, as already shown, beauty is a simple and primary quality, and no such quality

The Ferry Crossing at Sakasai (Sakasai-no watashi)

Utagawa Hiroshige, 1857
Woodblock colour print, 34.3 x 22.9 cm
Brooklyn Museum of Art, New York

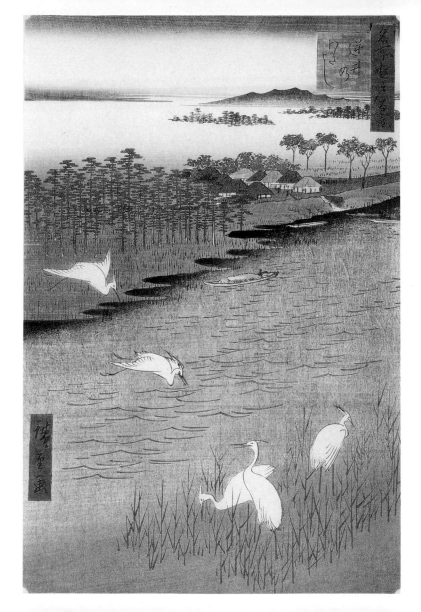

139

is the product of reasoning or judgment. No synthesis can reach that which is not combined, no analysis that which is not contained as a constituent in anything higher than itself. These two processes of reflection, therefore, have no power over beauty, and, if falsely applied to this idea, they immediately destroy it in its own peculiar nature, and confound it with some of the ideas of which they can take cognisance, as utility and fitness.

The Suidobashi Bridge and Surugadai

Utagawa Hiroshige, 1857
Woodblock colour print, 34 x 22.3 cm
Brooklyn Museum of Art, New York

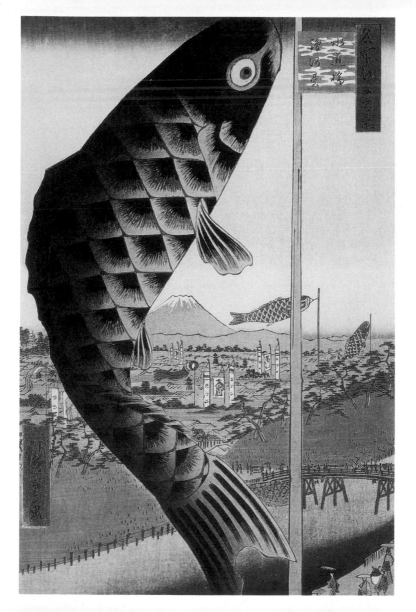

141

The third supposition, then, alone remains to us, that this notion is reached through an internal sense, an intuitive power of the reason. Nor is the necessity of the supposition its only proof. We have seen the quality, beauty, not to inhere directly in an external object, as sweetness in the peach or colour in its rind, but indirectly through certain other ideas and relations there present, as right belongs to an action which has certain bearings on the welfare of men.

Bulls

Constant Troyon
Oil on panel, 32 x 41 cm
Radishchev Art Museum, Saratov

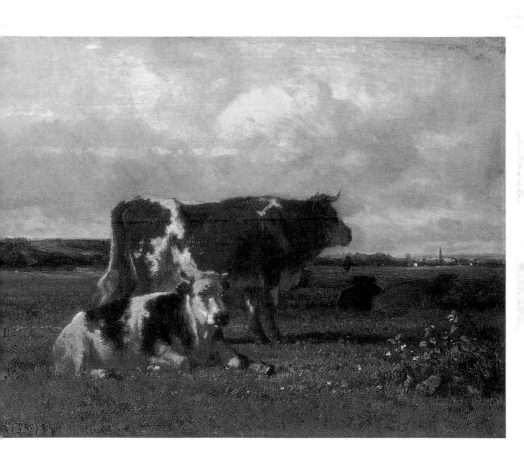

The basis of beauty, that in which it is discerned, may be said to be intellectual, and not sensual – a concept, and not an object; form, and not matter; an idea, and not the material which that idea orders. While, then, there is an intuition, we see it cannot be an intuition of the senses, for these only furnish matter in its properties, only act on the material, and the present intuition, going beyond this, must find its quality in a concept, an idea, itself apprehended and present by

White Bull and Blond Heifer

Gustave Courbet, 1851
Oil on canvas, 88.5 x 115 cm
Musée départemental Gustave Courbet, Ornans

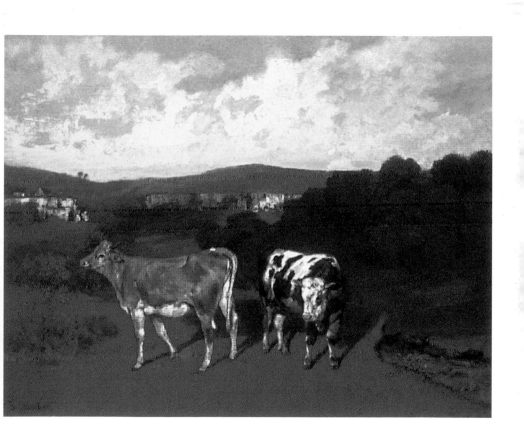

means of a sensation. The intuitive action, therefore, which reaches beauty must be preceded by sensation and be able to make the conception which sensation furnishes the mind its own object. In each material thing which is the product of design, there are present form and colour, given in sensation, and the design, the plan which these indicate, given in the intellect. It is this intellection which becomes the object of the intuition.

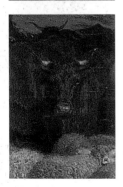

Landscape with a Herd of Sheep and Cows

Auguste François Bonheur, 1856
Oil on canvas, 52.5 x 46 cm
The State Hermitage Museum, St. Petersburg

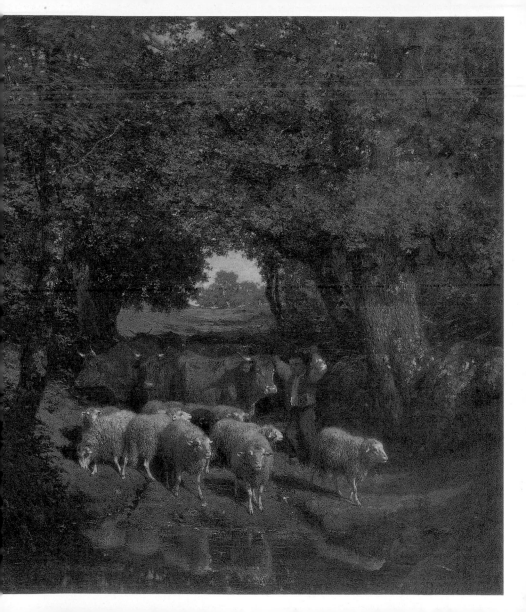

In a cognition of beauty, the steps are three; two presentative and one perceptive. These steps are: an object given in sensation; an action of the mind upon this object, by which it is understood, by which the idea in it is reached; the action of the reason on the idea, as unfolded in the intellect, and found in the object. The first and third of these steps are intuitions, the second, reflection. The third completes the others, and alone renders the quality beauty. The brute eye may perform the first; a simple power of thought, the second; and only

Susaki and Jumantsubo in Fukagawa

Utagawa Hiroshige
Fukagawa Susaki Jûmantsubo (i5/1857)
Woodblock colour print, 36 x 23.5 cm
Brooklyn Museum of Art, New York

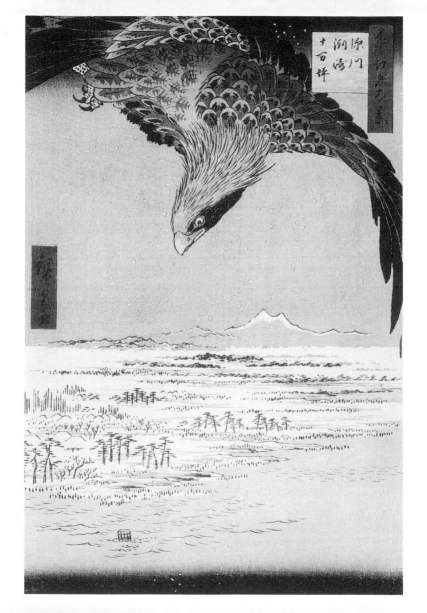

149

a mind gifted with the high, intuitive organ, reason, the third. It is not strange that the preliminary steps, especially the second, should be confounded with the third; that the reasoning processes, by which objects are understood in their relations, should be thought to furnish a quality of which they are the necessary antecedents; that the presence of a new power, by which we reach in the old a fresh and underived attribute, should be overlooked.

Horses (study)

Joseph Nicolas Robert-Fleury
Oil on canvas, 25.5 x 34.5 cm
The State Hermitage Museum, St. Petersburg

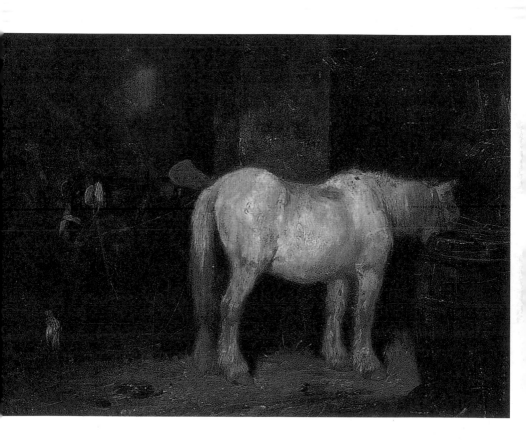

The object in other intuitions of the reason is an intellection, and, in this respect, beauty is entirely analogous to truth and right. The proposition as presented to the eye is not seen to be a truth. It is only when the reasonings which pertain to it are perfected that the reason, acting on it as now presented, pronounces it a truth. This is yet plainer in the perception of right. The action is merely given through the eye; nothing is as yet declared about it. It may be the product of intelligence,

Sheep in a Sheepfold

Charles-Emile Jacque, 1859
Oil on panel, 70 x 93 cm
The State Hermitage Museum, St. Petersburg

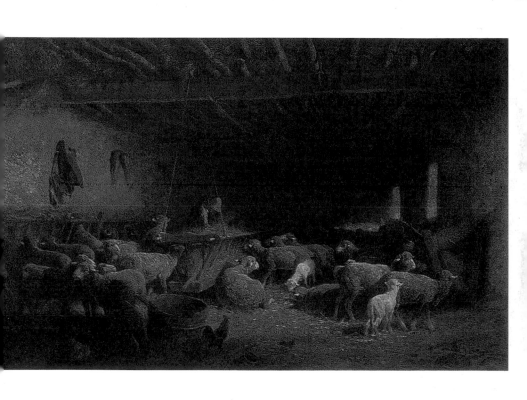

153

and thus right or wrong, and it may be the result of idiocy or insanity, and thus be destitute of the higher attribute. The fact alone is before the mind, and not its circumstances, its sources, and results. On this fact, however, the mind proceeds to act, determines the motive, inquires into the immediate and ultimate results of such action, and the degree in which its author understood these, or could have understood them. The action, in all its relations being laid open, the reason

The Spring Rut, Battle of the Stags

Gustave Courbet, 1861
Oil on canvas, 355 x 507 cm
Musée d'Orsay, Paris

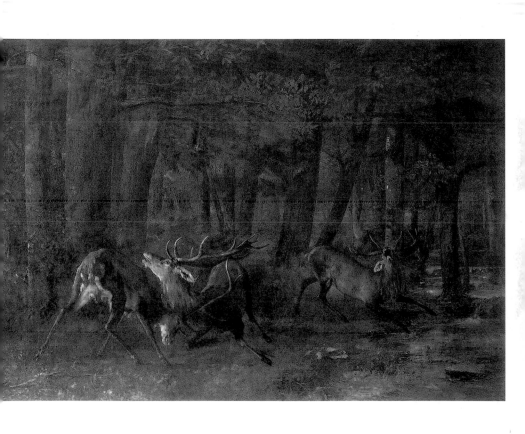

then discerns in it as so presented the quality, right, or the disregard of that quality, wrong.

The correctness of the reference of beauty to an intuitive faculty will be seen more and more at every step. It is so radical that all minor truths explain it and are explained by it.

The inquiry now arises, whether the decisions of taste tend to a common result – whether diversity is accidental and agreement permanent. The answer to

Still Life with Eel and Red Mullet

Edouard Manet, 1864
Oil on canvas, 38 x 46 cm
Musée d'Orsay, Paris

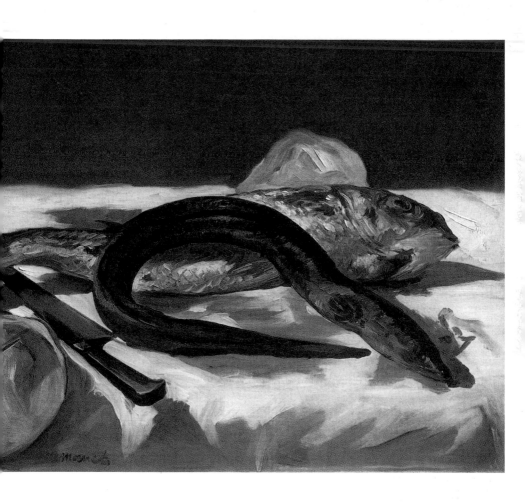

this question must depend on the intuitive faculty, on the further question whether this admits in its action variety or is the same for all. The reason must be the final referee in questions of beauty, equally in nature as in art, and if its judgments conform to no law, and establish no standard, then there is no basis of agreement or of science in this department. The individual may have his own principles; but as between individuals all is caprice. Nature and art in their variety may be judged, but as

The Greyhounds of the Comte de Choiseul

Gustave Courbet, 1866
Oil on canvas, 89.5 x 116.5 cm
Saint Louis Art Museum, Saint Louis

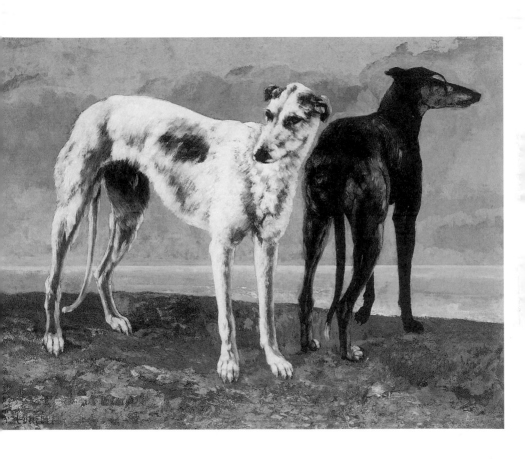

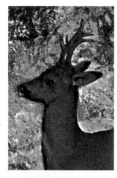

sustaining this or overthrowing that judgment nothing can be said.

That the intuitions of reason agree with themselves and establish a standard is sustained by arguments plain and familiar, and requiring but a brief presentation.

It is probable that an intuitive organ, whose office it is to impart, to perceive, would, in the same things, perceive and impart the same qualities.

If such an organ is a source of knowledge, renders truth, it must yield that which is objectively present in

The Change, Scene from a Deer Hunt in
Franche-Comté

Gustave Courbet, 1866
Oil on canvas, 97 x 130 cm
Ordrupgaardsamlingen, Copenhagen

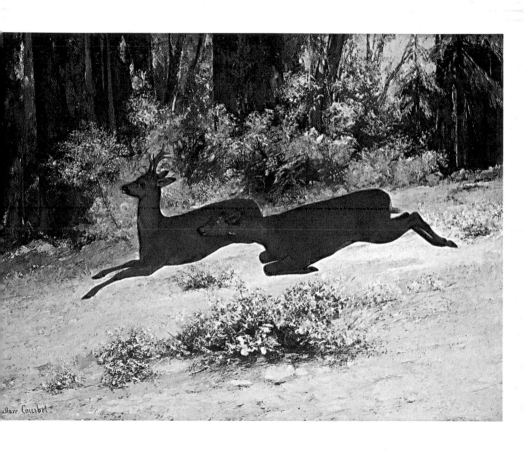

161

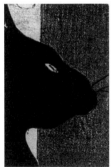

things, and this must be the same to every recipient. Our physical senses, it may be said, are not accurate, admit of considerable variety, and render a similar discrepancy probable at other points where it is less easily detected. Taste affords an illustration of this disagreement. To this, it may be answered that this variety is not such as to interfere with the office of this sense, that the organic impression is relatively much greater in the lower than in the higher organs of sense, that pleasure,

The Cats' Rendez-Vous

Edouard Manet, 1868
Lithograph, 43.5 x 33.2 cm
Bibliothèque nationale de France, Paris

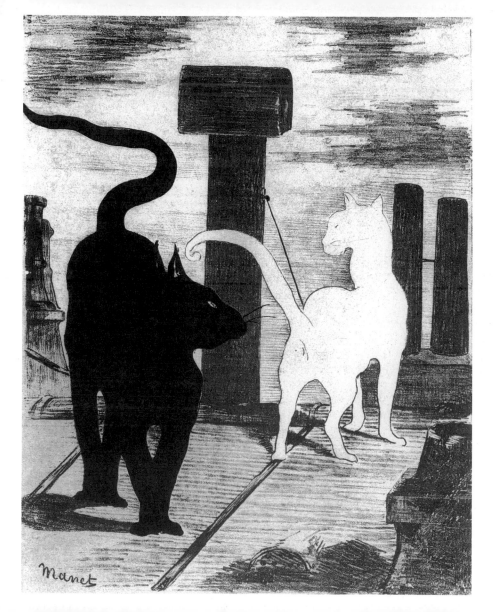

rather than knowledge, is there aimed at, and that it is consistent, therefore, both with the nature and office of the organs of taste and smell, that these should, more than other organs, modify what they transmit. The eye and the ear, on the other hand – the great gateways of knowledge – we have every reason to believe, if we cannot always prove it, give the same information to all. The reason is the organ of our highest intuitions is utterly destitute of any organic sensation or satisfaction, and is

Horses in a Meadow

Edgar Degas, 1871
Oil on canvas, 31.8 x 40 cm
National Gallery of Art, Washington, D.C

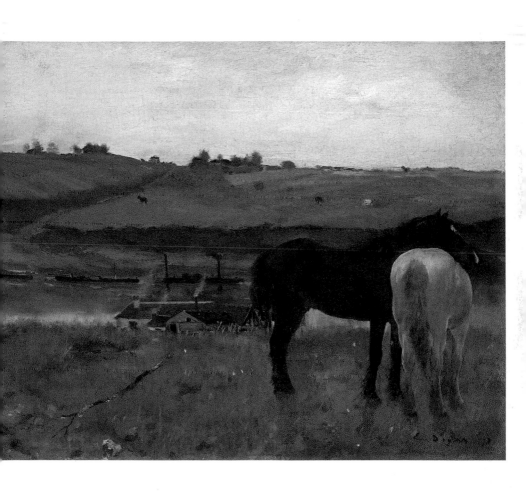

solely dependent for the enjoyment which it confers on the knowledge it transmits on the quality whose presence it affirms. If, then, this quality has not a substantial existence, witnessed to by this faculty, the veracity of the faculty is impeached, its pleasure is a hallucination, and we have in our intellectual apparatus a power which avouches a truth where no opportunity for such a truth exists, and leaves us, not only satisfied, but delighted with the falsehood. This presents a case wholly different

Still Life with Dead Game

Hippolite Robillard, 1875
Oli on canvas, 132 x 106 cm
The State Hermitage Museum, St. Petersburg

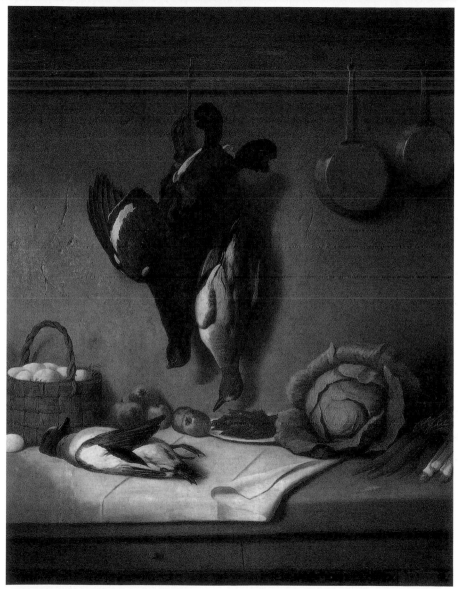

167

from any variety in pleasurable sensations. That an organ whose office it is merely to receive and to testify to its own impressions should show some discrepancies is not strange; but that an organ whose office it is to report the most important and controlling principles in the realms of things, of belief, of action, which has committed to it beauty, truth, and right, should involve the mind in an inextricable labyrinth of falsehood, or, rather, through the want of any standard, destroy all

Young Bull in a Meadow

Edouard Manet, 1881
Oil on canvas, 79 x 99 cm
Private collection

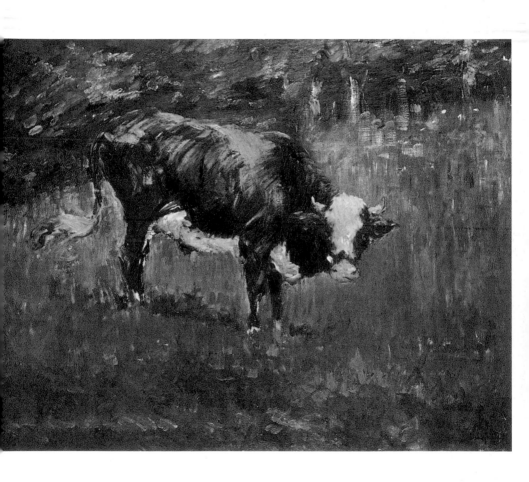

idea of truth, is wholly inconceivable, utterly destructive of all faith in our faculties. A scepticism so radical destroys itself. Beauty is the most universal law of form, the most potent guide of method found in the external world. It includes all lower utilities and adaptations, and adds for the reason of man a most magnificent utility of its own. Beauty and utility are not dissevered or conflicting, but concurrent ends. Beauty includes the perfection of uses, and only in such manifestation of perfection is

The Kingfisher

Vincent van Gogh, 1886
Oil painting, 19 x 26.5 cm
Van Gogh Museum, Amsterdam

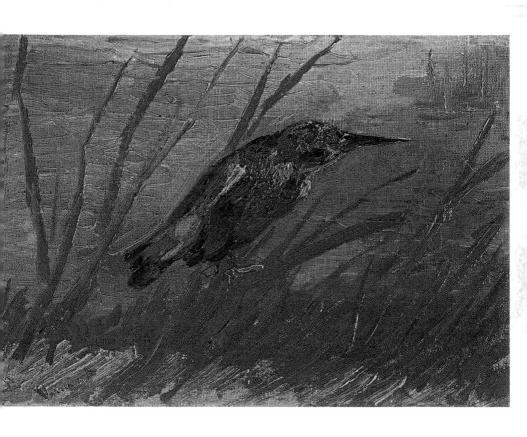

there beauty. If, then, this principle, which rules the external into a noble completeness, which is everywhere present, securing perfection and symmetry of plan, and skill of execution, is visionary, well may we afterward expect that the principle of right, giving form to moral action and truth, shaping all belief, should, being witnessed only by the same faculty, be, also found illusory.

A second proof of the integrity of our intuitions is the practical faith which all men repose in the decisions of

Morning in a Pine Forest

Ivan Shishkin, 1889
Oil on canvas, 139 x 213 cm
Tretyakov Gallery, Moscow

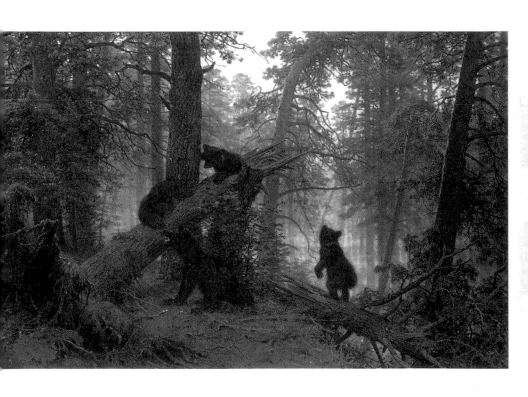

173

reason, and which they evince by reasoning with their fellows. This perpetual resort to argument implies, not only that there is common ground, common and truthful faculties acting upon facts, but a reasonable expectation that, with explanation and increased insight, corresponding views and convictions may be reached. Without a unity, a oneness of powers, all such methods were utterly useless and absurd. How, then, do we always deem them rational, and often find them successful?

Crab on its Back

Vincent van Gogh, 1889
Oil on canvas, 38 x 46.5 cm
Vincent Van Gogh Foundation, Amsterdam

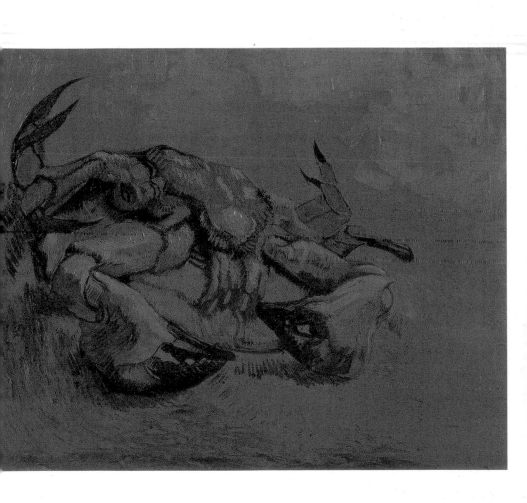

A third consideration is the agreement actually existing among men on questions of taste. This may seem an inversion of the chief argument of our adversaries – the disagreement among men concerning the things thought beautiful. Every belief, however, must, in the last appeal, rest not on argument, but on a skilful and careful interpretation of facts. We shall shortly point out the occasion of variety in men's intuitions, and now note the kind of agreement in their judgments which, amid all discrepancies, indicates a radical unity of taste.

Two Poodles

Pierre Bonnard, 1891
Oil on canvas, 36.3 x 39.7 cm
City Art Gallery, Southampton

(a.) An agreement which becomes more complete as men better understand each other and themselves indicates a oneness of controlling principles. A superficial agreement is most striking at the outset, and is rapidly lost as investigation proceeds. The reverse is true of a deep, interior unity. In all questions of taste, the lines of opinion, as they come up through the progressive stages of civilization, are found to converge.

Neptune's Horses

Walter Crane, 1892
Oil on canvas, 86 x 216 cm
Neue Pinakothek, Munich

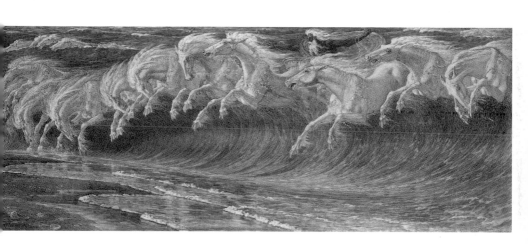

(b.) Akin to the proof of unity, derived from the greater agreement of the masses as they pass up in intelligence, is the fact that in each community, while the violence of controversy is found with artists and connoisseurs, here also is found the greatest number of admitted principles. The controversy and the principles equally prove that the right, though disputed, is felt somewhere to exist.

The Tiger

Paul Ranson, 1893
Colour lithograph
Jane Voorhees Zimmerli Art Museum,
Rutgers University, New Brunswick, New Jersey

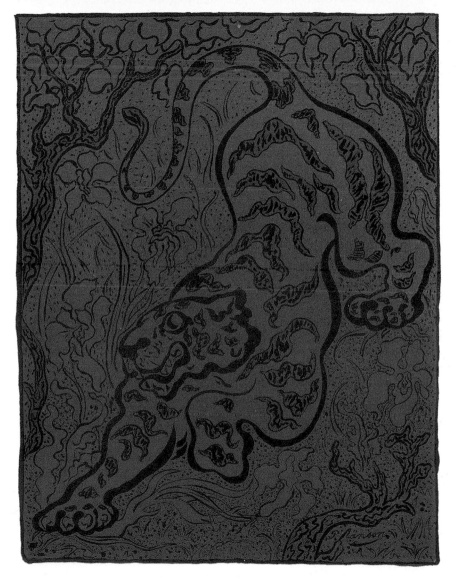

(c.) A concurrence in the kind, though not in the degree, of awards which different persons assign the same work, evinces a unity of principles, with only a transient variety in their application.

(d.) Disagreements which are themselves perpetually changing, settling into no law, agreements which, once established, are becoming principles, more and more controlling, unite to show the accidental character of the former, and the inherent and radical nature of the latter.

Common Foxes in the Snow

Friedrich Wilhelm Kuhnert, 1893

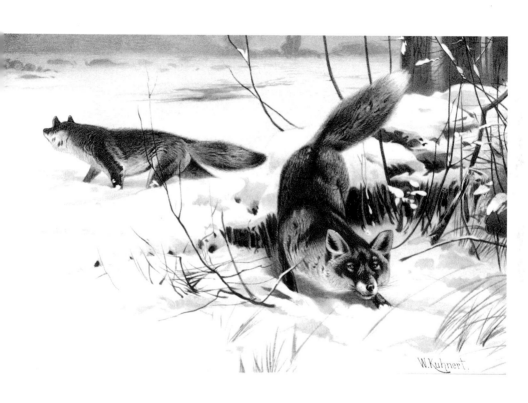

As, amid all discrepancies, there is yet in the facts these essential agreements, they obviously demand a likeness for their explanation of powers, and an ever increasing sameness of action.

It is not now a difficult task to assign a reason for the transient varieties of such obtrusive opinion found everywhere. We saw the second step by which an intuition is reached to be the transformation of a sensation into a conception, an idea; in other words, the

The White Cat

Pierre Bonnard, 1894
Oil on cardboard, 51 x 33 cm
Musée d'Orsay, Paris

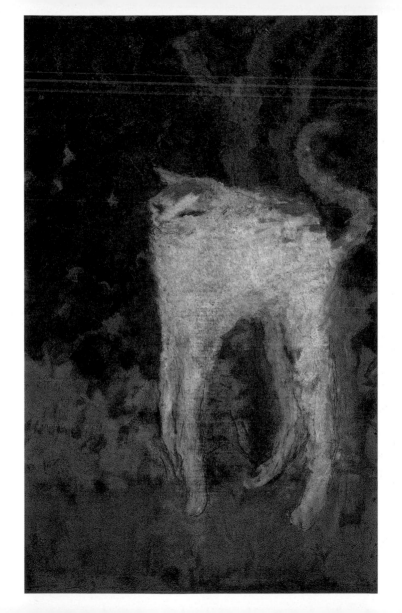

apprehension, on the part of the intellect, of the thought, the plan, contained in the object. Now, as the external and internal relations of the object are often most complex, and this thought, therefore, most deep and inclusive, it is not strange that the mind should reach it with difficulty and imperfectly; if with difficulty, its own task-labour and the slipping grasp of the understanding will weaken the impression of the object, and mar its beauty. Indeed, what is secured with the fatigue and delay of intellectual

Two Cats

Théophile Steinlen, 1894
Tempera on unprimed canvas, 61 x 64 cm
Pushkin Museum of Fine Arts, Moscow

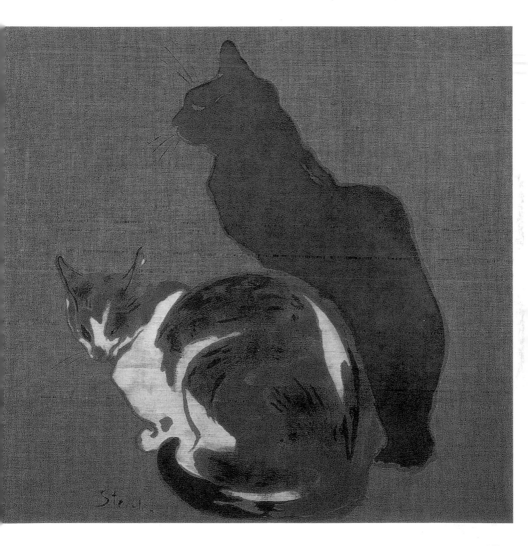

action is rarely regarded as beautiful; the mind demands the rapidity and fullness of vision. If the thought performs its work imperfectly, each imperfection will limit and modify the reason's estimate of what it has obtained, and an inevitable variety will spring up in its decisions. This very variety marks how closely reason clings to the truth of the fact before it, limiting its own judgments by the limitation which the intellect has already imposed on it. It is plain that the idea or concept which is furnished

Tarari maruru (Landscape with Two Goats)

Paul Gauguin, 1897
Oil on canvas, 92 x 73 cm
The State Hermitage Museum, St. Petersburg

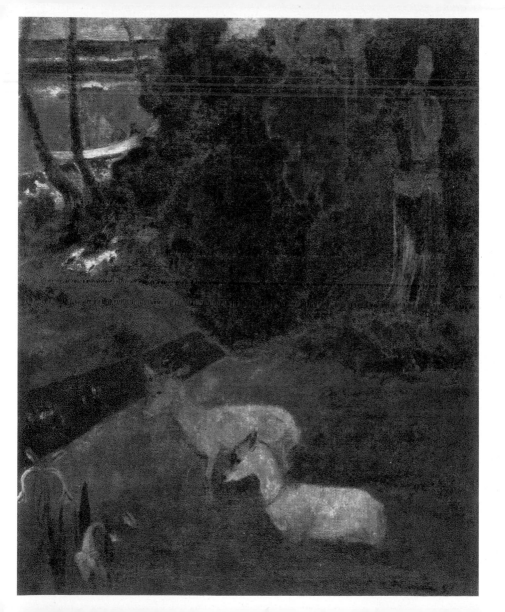

to the reason, and in which alone it sees beauty, will be as various as the powers and culture of the minds whose product it is, and that there must therefore be kindred discrepancies in the decisions of taste.

It is not affirmed that reason sees the same beauty in different conceptions, but in the same conception as realised in an object. But no complex object replete with thought communicates precisely the same impressions to understandings so various in their native and acquired

Still Life with Parrots

Paul Gauguin, 1902
Oil on canvas, 62 x 76 cm
Pushkin Museum of Fine Arts, Moscow

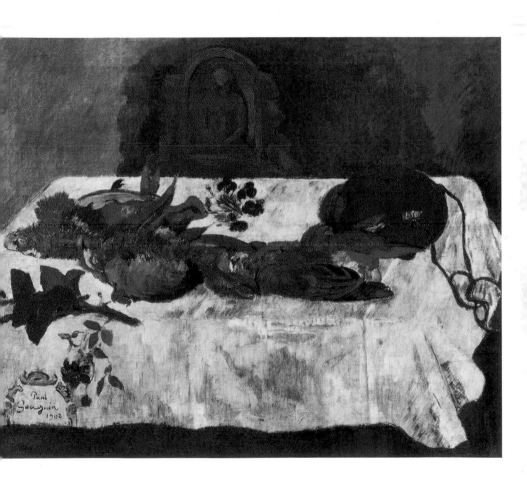

powers as those of men. We find our most apt illustrations in the kindred questions of right.

Right inheres in action, but the reason cannot safely pronounce on action until it sees it; that is, until it knows it in its motive, its present relations and final consequences. But an exhaustive inquiry of this sort is often most laborious, and the intellect doing its work weakly, wickedly, or indolently, reason is left to pronounce on a partial or perverted statement of facts, and hence to

The Merry Jesters

Henri Rousseau, 1906
Oil on canvas, 145.7 x 113.3 cm
Philadelphia Museum of Art, Philadelphia

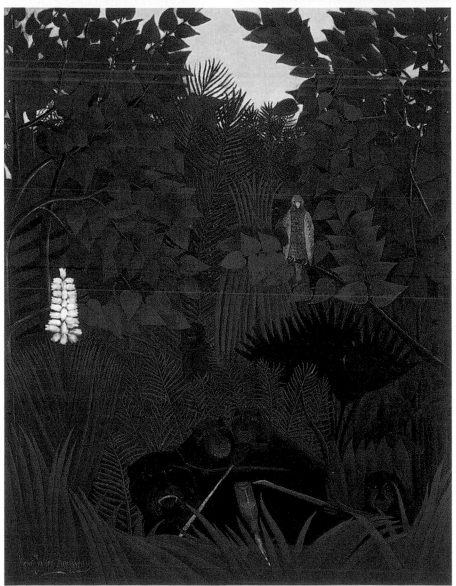

give a verdict, not only at war with truth, but with other verdicts given with kindred carelessness.

Here also we see the force which belongs to argument. It does not persuade or warp an intuition; this, the premises being given, is as fixed as fate. It strives to modify the premises, to affect the intellectual conception on which the reason is to pronounce. Either for right or for wrong, it leads the unbribed taste and conscience to its own position, as Balak, the incorrigible

A Horse Study

Frederic Remington, 1908
Oil on canvas, 63.5 x 63.5 cm
The Frederic Remington Art Museum
Ogdensburg, New York

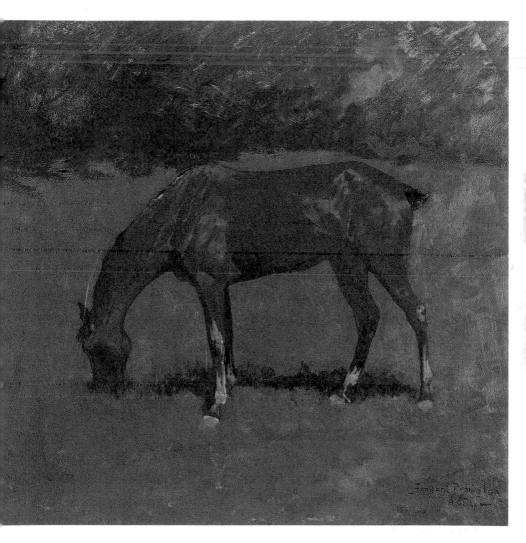

prophet, to Zophim, that it may have its enemies cursed from thence. Not more numerous on the retina of the eye than on the field of thought are the possible presentations of a given landscape; the very variety, therefore, which seemed at first to impeach the reason acquits it. This judge of things and actions, incorruptible in itself, has yet no power of investigation. Wicked witnesses and hired advocates may so render the facts as to make

Fight Between a Tiger and a Buffalo

Henri Rousseau, 1908
Oil on canvas, 170 x 189.5 cm
The Cleveland Museum of Art, Cleveland

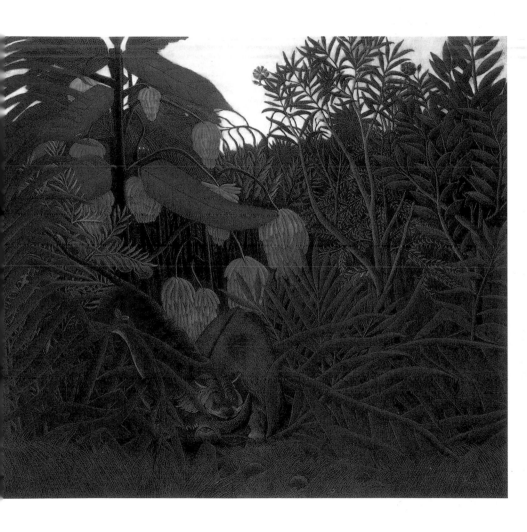

its integrity of no avail, and the united falsehoods of the heart and the head find transient currency under its seal.

The faculty, reason, is incapable of any direct culture. Like the eye, it seeks at once, and only seeks exercise. Taste, however – for it is better to include in this term the presentative as well as the perceptive action of the mind – may be trained, and that chiefly through the second of the steps by which a judgment of the reason is reached.

Study of a Horse

Franz Marc, 1908-1909
Oil on cardboard on canvas, 40 x 26 cm
Private collection

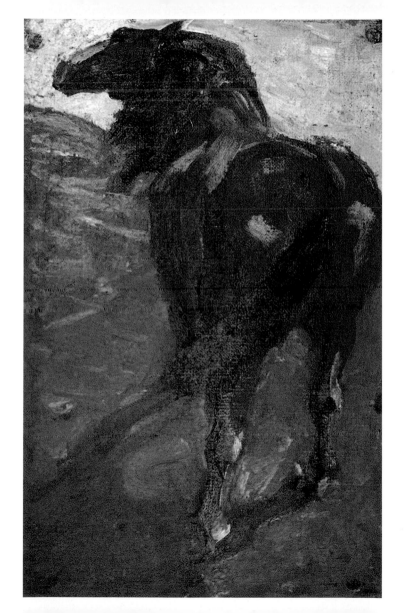

Of these three, the first is intuitive, the second reflective, and the third again intuitive; the first sensational, the second intellectual, the third rational; each part of our triple nature uniting in the judgments of taste. Action is the strengthening agent of our intuitive faculties; our reflective powers, on the other hand, are, in addition largely dependent for their present efficiency on past work, on facts disposed of and principles established.

Moonlight, Wolf

Frederic Remington, c. 1909
Oil on canvas, 50.8 x 66 cm
Addison Gallery of American Art, Phillips Academy
Andover, Massachusetts

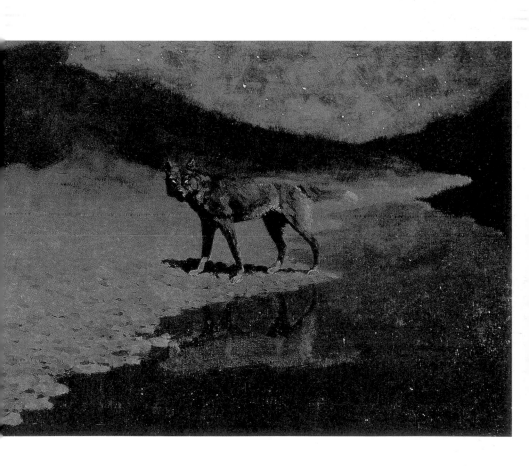

The rapidity and correctness with which the mind arrives at judgments on new matter presented to it, depend almost wholly on the use which it has hitherto made of its reflective powers, gathering up and explaining the phenomena about it in appropriate principles. So far as it understands the forces and laws at work in a given department, and has familiarised itself with every class of facts, will it be able at once to refer each new appearance to its appropriate place,

Horse Attacked by a Jaguar

Henri Rousseau, 1910
Oil on canvas, 89 x 116 cm
Pushkin Museum of Fine Arts, Moscow

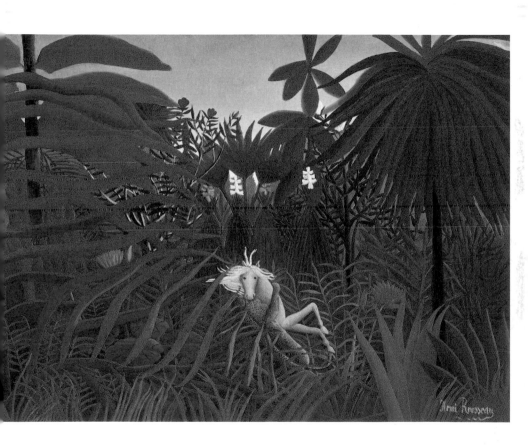

and give to a reflective process the quickness and ease of an intuition. In this direction is it that the mind is chiefly disciplined. If the field is that of aesthetics, all knowledge which acquaints the mind with the office and habits of any flower, shrub, tree, insect, bird, or beast, will enable it the more perfectly to comprehend its form and adaptations, and through these the plan which, in its perfect execution, renders it beautiful.

Little Blue Horses

Franz Marc, 1911
Oil on canvas, 61 x 101 cm
Private collection, Hamburg

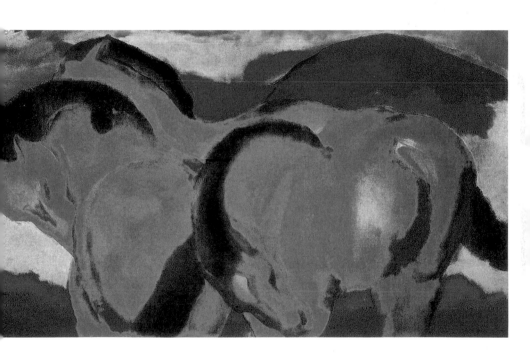

All knowledge which acquaints the intellect with the force of the several symbols of expression, and enables it readily through these to reach the formative thought, which defines the conditions under which alone the mind receives pleasure and familiarises the principles which rule our enjoyments, will prepare the way for speedy and just decisions of taste. He whose past experience is classified and labelled, does not start

Blue-Black Fox

Franz Marc, 1911
Oil on canvas, 50 x 63.5 cm
Von der Heydt Museum, Wuppertal

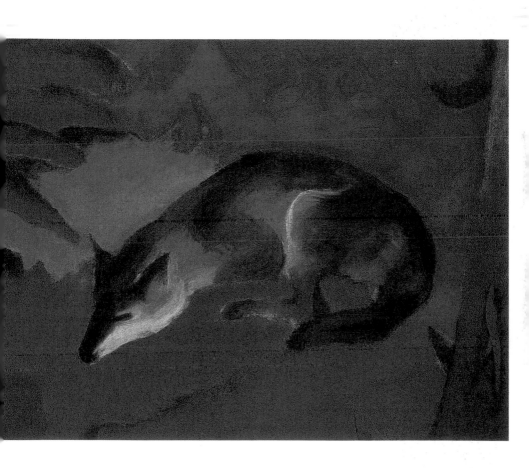

anew in each judgment, but has the labour of past years at instant command.

In morals, he who has long and cautiously applied the laws of action to the questions of life will be able to speedily refer each new case to its appropriate explanatory principle, and with an intuitive faculty no more just and certain in its action than that of another, reach his conclusion with all the correctness and wisdom which have characterised his past elementary judgments.

Yellow Cow

Franz Marc, 1911
Oil on canvas, 140 x 190 cm
Guggenheim Museum, New York

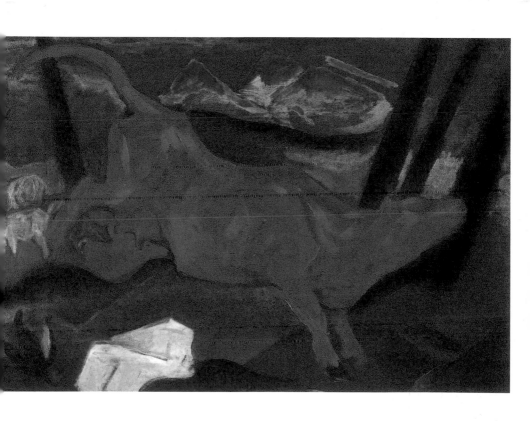

Many of the considerations which guide in questions of taste, and which are ever-present to the wise critic are still to be pointed out, but enough has already been done to show that the reflective processes, which prepare the way for a speedy and safe intuition, are so numerous as to render skill the result of much training. Most of the questions of life are so complex as to require many antecedent judgments for their resolution. These, each man brings with him, and accordingly as they

Red Fish
—————

Henri Matisse, 1912
Oil on canvas, 140 x 98 cm
Pushkin Museum of Fine Arts, Moscow

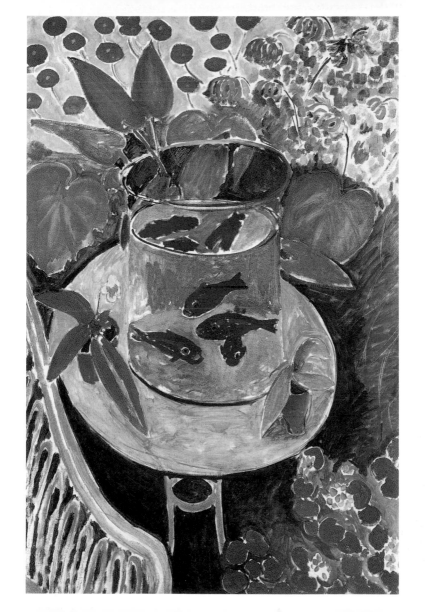

contain the complicated errors or the corrected wisdom of a life, which will be the immediate result. False figures once introduced into the solution of a problem, are carried on and multiplied through the whole process. The chief method, then, by which we reach correct intuitions, is a careful formation of elementary and preliminary judgments.

A second method of culture is securing integrity and purifying it in our own spirits. Health is requisite to the

Lyrics

Wassily Kandinsky, 1911
Oil on canvas, 94.5 x 130 cm
Museum Boijmans Van Beuningen, Rotterdam

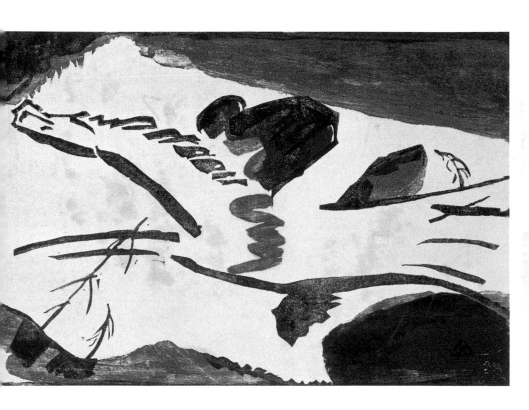

love of that which is healthy; while a lascivious, lustful heart will seek lascivious and lustful art. If the wisdom and grace of the thought, as it comes out in a noble product, are alone to elicit our admiration, there must be an intense sympathy in the spirit with that which is grace-giving and true, and a stern rejection of that which is wayward and ready to slip into base debauchery. The great bulk of error in morals is traceable back of

Red Deer II

Franz Marc, 1912
Oil on canvas, 70 x 100 cm
Bayerische Staatsgemäldesammlungen
Pinakothek der Moderne, Munich

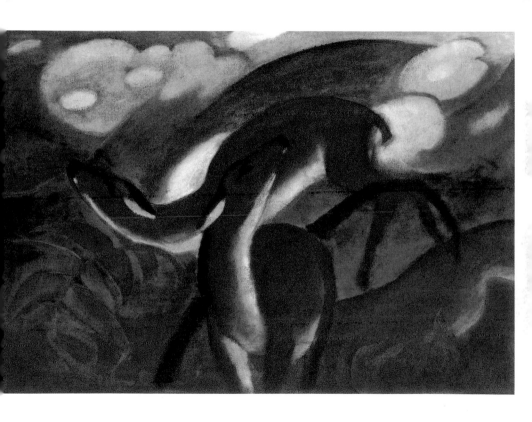

the intellect to the inclinations, whose servants the thoughts are. The mind has not done its work well, because it has not been left free to take its own positions, but has been made to fortify each outpost of vice in which the heart chose to tarry. To a lesser degree, yet in a very sensible and unfortunate degree, men have weakened their appreciation of true beauty, and especially of human beauty, through a want of sympathy with the noble and true impulses which inspire it.

The Tiger

Franz Marc, 1912
Oil on canvas, 111 x 111.5 cm
Städtische Galerie im Lenbachhaus, Munich

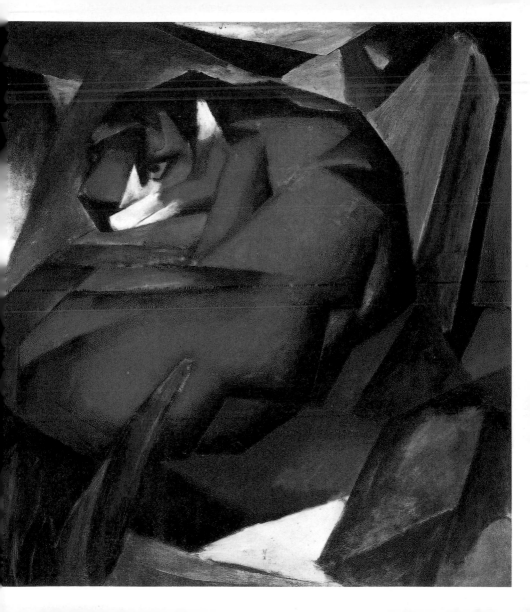

The world is full of God's conceptions, and he who would enjoy them must at least have sympathy with God as a worker. If to be high and to be holy are the same in man, or at least the completion of the same impulse, then he will best understand the high who rightly apprehends the holy. We here and everywhere deny beauty to that which is seen to degrade; and it is certainly true that a spirit firm in its own integrity, and waiting ever for the Divine word, will only see beauty in

The Mandrill

Franz Marc, 1913
Oil on canvas, 91 x 131 cm
Staatsgalerie Moderner Kunst, Munich

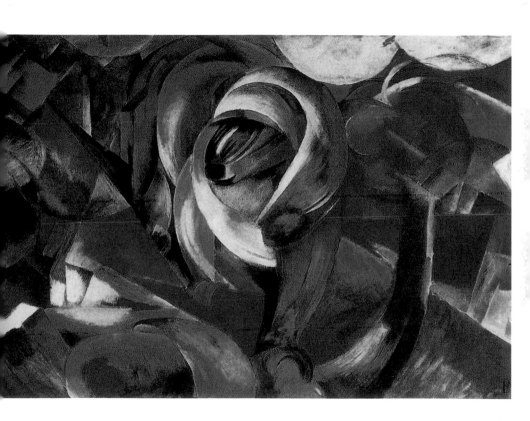

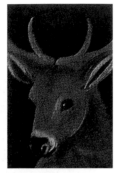

that in which it sees truth and worth. Beauty, though the weaker of the three, is never totally disjoined from truth and right, never keeps company with entire falsehood and baseness.

So akin, also, is reason in its several kinds of action, so allied are the reasoning processes by which we prepare the way for its several intuitions, that all training in the search after right will aid in the discipline of taste. This connection is sufficiently shown by the constant

A Deer Family

Niko Pirosmani, 1917
Oil on cardboard, 95 x 145 cm
Collection of the Grammeleki family, Tbilisi

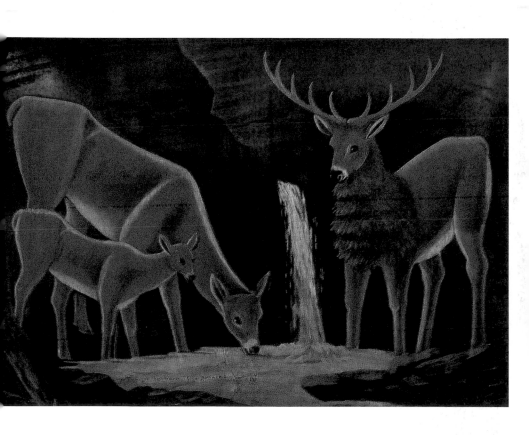

reference we have had occasion to make, for purposes of illustration, to the department of morals. In both departments there are subtle laws of action, each with its own imperative, the one weaker, the other stronger. He who can neglect that which is right in action will readily neglect that which is beautiful, and he who can despise that which is beautiful in action will the more easily despise that which is right.

Young Owl

François Pompon, after 1923
Bronze with green and brown patina, 19 x 8.5 x 8.2 cm
Musée d'Orsay, Paris

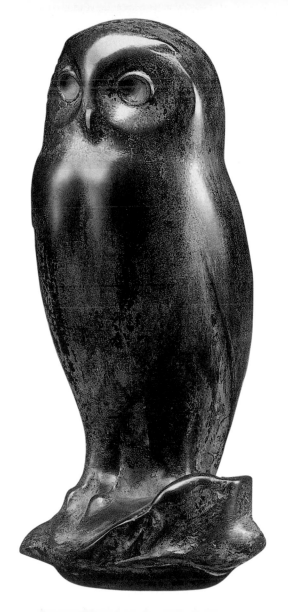

What has now been said of the culture of taste, while leaving in their validity the decisions of reason, yet showing the impossibility of an absolute and perfect standard for the present guidance of men. Indeed, no such thing is desirable if so applied as to preclude that progress which with man is infinitely more than immediate possession. No decision of taste, however correct, can be seen to be correct save by one who has equally thoroughly canvassed the conditions on which it rests.

Little Horse
─────────────

Pablo Picasso, 1924(?)
Indian ink on paper, 21 x 27.2 cm
The State Hermitage Museum, St. Petersburg

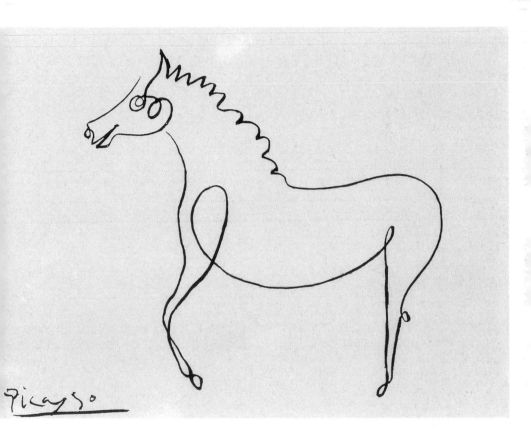

However so many, therefore, there may be of right judgments on the beauties of nature and art, these judgments do not stand forth with any peculiar lustre as guides for men until the public taste has itself arrived at that point in which it can appreciate and confirm them.

No individual can much avail himself of a standard higher than his own. Under the training of more powerful minds, he bears his own standard, and the height of his achievement is mailed by the position at which he halts at length. The possibility of entire and

The Golden Fish

Paul Klee, 1925
Oil and watercolor on paper, 49 x 69 cm
Hamburger Kunsthalle, Hamburg

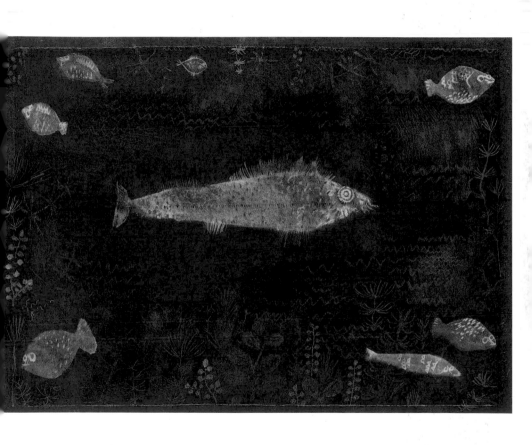

universal correctness, and hence of uniformity in the decisions of taste, is the possibility of entire fullness and precision in our reflective processes and perfect integrity in our impulses. Such a state is a remote ideal, approximated by slow and laborious, yet constant, progress. The ideal is ever something to be won and not given, to be possessed in trained and conscious power, and not in native capabilities. It is the possible waiting to be made real in effort, the latent to be revealed in action.

Cat and Bird

Paul Klee, 1928
Oil and ink on gessoed canvas
mounted on wood, 38.1 x 53.2 cm
The Museum of Modern Art, New York

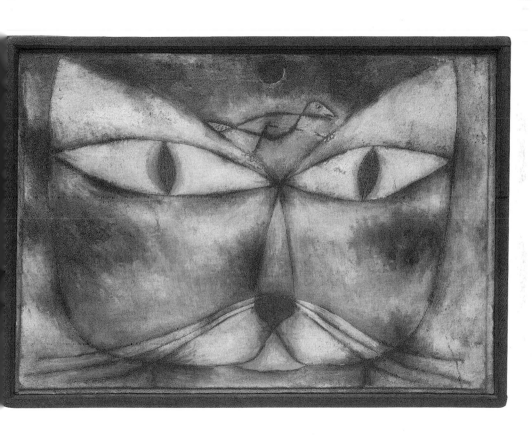

It remains, in connection with the faculties by which beauty is arrived at, to point out the action of the imagination and the distinction between this and fancy. Imagination finds its most constant employment in reproducing that to the eye of the mind which has been given in the senses. The impressions of the senses are transient, but the mind does not lose its power over them; when they have passed from these, its external organs, it is yet able to recover them and repeat them

Time is a River without Banks

Marc Chagall, 1930-1939
Oil painting, 100 x 81.3 cm
Collection Ida Chagall, Paris

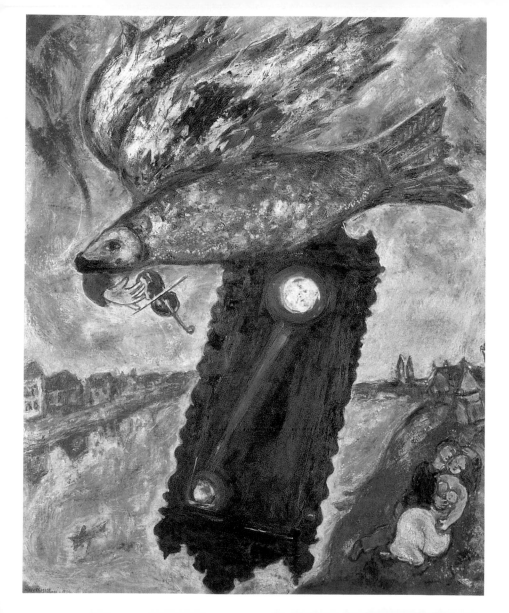

to itself through the faculties of memory and imagination. The memory guides the imagining power, and this reconstructs on the mental field what was before contained in the organ of sense. This takes place most distinctly in the matter given in vision, and it is sufficient for our present purpose to confine our attention to this sense, through which the symbols of beauty chiefly enter.

Not only does the imagination render to us copies of scenes remembered under the guidance of description,

Tiger
———

Morris Hirschfield, 1940
Oil on canvas, 71.1 x 101.3 cm
The Museum of Modern Art, New York

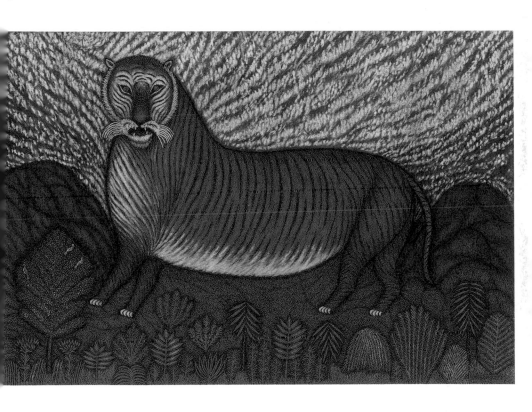

233

it constructs more or less accurate representations of things reported by others, and in vacant hours gives to it medleys, scraps of many things present before. Nor is this all; while never escaping from the form under which the senses work, it often, under the influence of desire, renders combinations and images which, as a whole or in appreciable parts, may never have been seen or described. The air-castles of every enthusiastic dreamer are of this character.

Cow with Parasol

Marc Chagall, 1946
Oil on canvas, 75 x 106.6 cm
Richard S. Zeisler Collection, New York

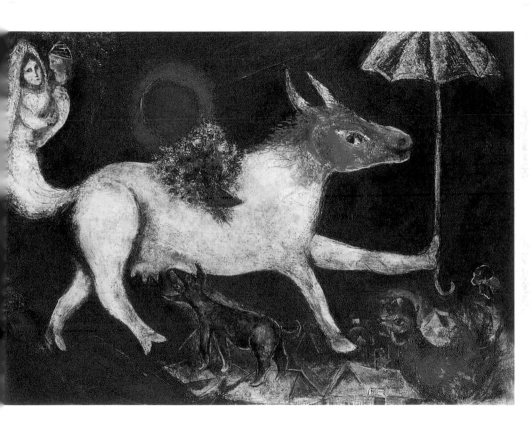

Desire gives the law and subject-matter of the picture, while imagination paints it. There is a perpetual tendency to furnish out these scenes from the store-house of memory, and yet they are often far from being mere counterparts of remembered objects. The imagination is thus a facile instrument in the hands of desire, bringing immediately before the appetite a full gratification, and perpetually inflaming it with its tantalising proffers.

She-Goat

Pablo Picasso, 1950
Bronze (cast 1952), after an assemblage of palm leaf,
ceramic flower pots, wicker basket, metal elements and plaster
120.5 x 72 x 144 cm
Museum of Fine Arts, Houston

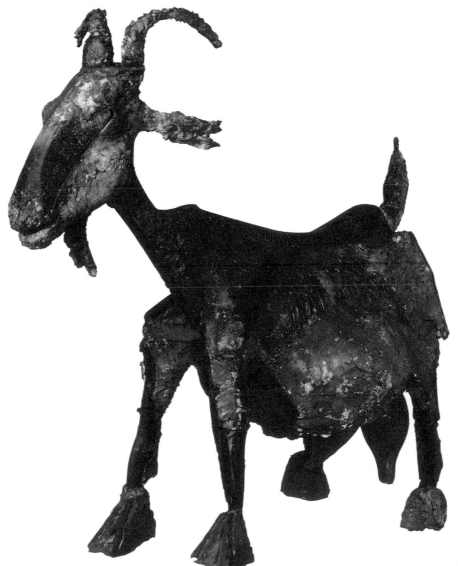

237

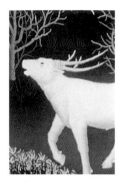

All the lures of effort are lodged in the imagination, and thus it becomes a potent means of good or evil in the government of the mind.

This same power not only works under the impulse of passion, but under that of reason, and realises for the mind its intuitions of beauty. When the mind has mastered the symbols of expression, and has in it a feeling to be uttered, the imagination, under the guidance of reason, unites the two, and a distinctly uttered sentiment,

The Deer Wedding

Ivan Generalic, 1959
Oil on glass, 43 x 68 cm
Private collection

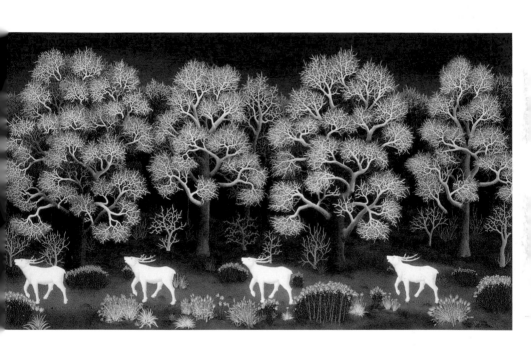

a realised beauty, a creation, lies before the mind. The impulse, the feeling, is furnished by the heart, the conception which beautifully utters it by the reason, the symbols of utterance by past observation, and the realisation of these to the vision of the mind by the imagination.

The reason acting on that given in the senses is simply intuitive and critical; acting with the imagination, is creative and productive, and thus supplements nature

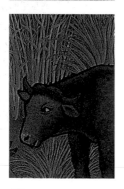

Fluvial Landscape

Ivan Generalic, 1964
Private collection

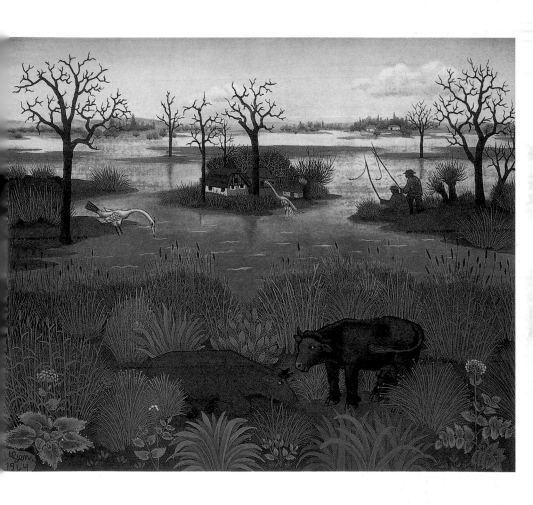

with art. The imagination then comes in to aid and realise the highest mental efforts, and the mind, no longer merely a recipient – cultured and watered – begins to blossom and bear fruit.

There is another action of the imagination less high and valuable than this, which is appropriately termed fancy. It is a pleasing rather than expressive use of form and colour – that limited play which is given to this creative faculty in schools of design.

Panda Bear

Andy Warhol, 1983
Acrylic paint and silkscreen on canvas, 24.9 x 19.9 cm
Bruno Bischofberger Gallery, Zurich

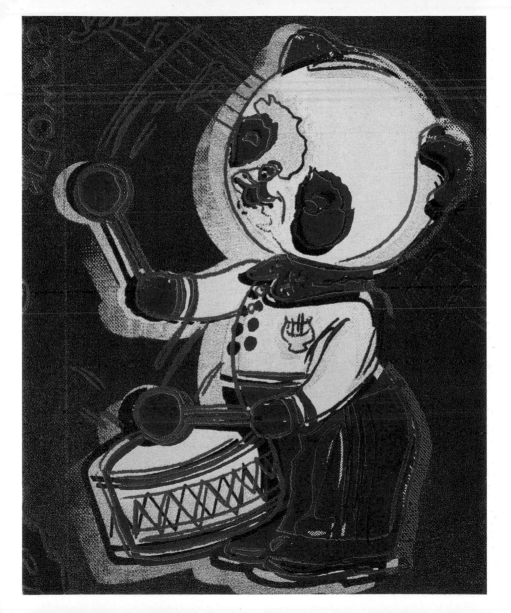

Members pleasant in themselves are united in agreeable lines, and without compassing any thought the plan returns gracefully into itself. There is not disorder, nor yet is there any significant order. There is not a completion and correspondence of members, nor is each absolutely fragmentary and unconnected. A half-aimless and half-idle, yet ever graceful and powerful movement of mind is indicated, with single strokes in fine perfection here and there.

Parrot #3

Andy Warhol, 1983
Acrylic paint and silkscreen on canvas, 24.9 x 19.9 cm
Bruno Bischofberger Gallery, Zurich

This fantastic, sportive movement of a mind too unoccupied to feel deeply, and too full to do anything absolutely meaningless, is fancy.

It is evident that the lower and the higher action of imagination, art, and fine art, cannot be cut asunder by a straight and well-defined line. Genius at work employs imagination; at sport, fancy. Each is the same reproductive faculty, under a higher and sterner, or lower and milder, impulse.

Terrier

———

Andy Warhol, 1983
Acrylic paint and silkscreen, 35.8 x 27.9 cm
Bruno Bischofberger Gallery, Zurich

MECHANICAL Terrier

NOT RECOMMENDED FOR CHILDREN UNDER 3 YEARS AGE.

Index of Illustrations

F

G

H

T